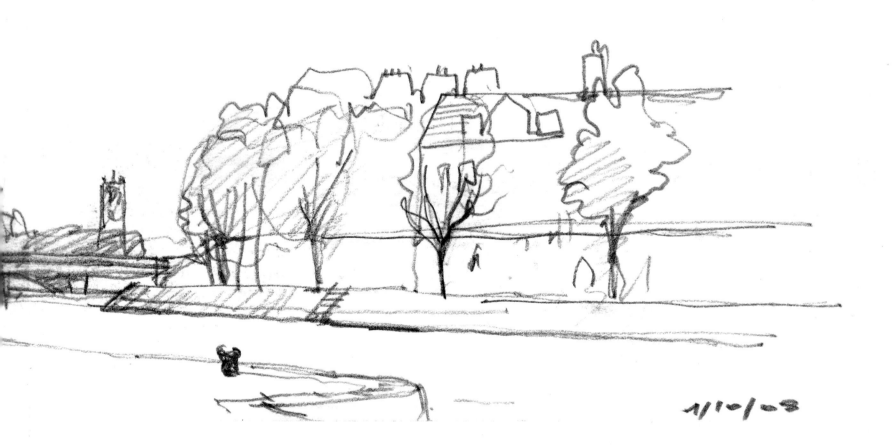

1/10/08

# DRAWING PERSPECTIVE
## Freehand

GILLES RONIN

A & C BLACK

First published in great Britain 2011
A&C Black Publishers
36 Soho Square
London W1D 3QY
www.acblack.com

ISBN: 978-1-4081-3449-8

A CIP catalogue record for this book is available from the British Library.

Editorial director: Colette Hanicotte
Editor: Corinne de Montalembert
Assisted by Natalia Dobiecka
Layout: Florence de Maux
Proofreader: Pierre Valas
Production: Anne Reynaud
Photograph page 6: Olivier Ploton
English text layout: Susan McIntyre
Translation: Alexa Stace
Assistant Editor: Ellen Parnavelas

Printed and bound in China.

# Contents

3

# Introduction

This book proposes to teach you how to make sketches in perspective: everyday objects, study sketches for a conversion or architectural project, landscapes and much more.

If the word sketch connotes rapidity and freedom, perspective connotes reflection and method. This contradiction is not always apparent, for when we make a sketch we are usually applying principles of perspective that were absorbed a long time ago. When a beginner struggles to get a result, it's often because he/she has run up against elementary questions of perspective.

The approach in this book is to show perspective in an empirical manner, by little practical steps, so as to be able to draw freehand. I propose therefore that you should read this book with a sketch-book at hand, reproducing the drawings one after another, for it is the best way to take in what is being explained. It is also the best way to make progress, for the freedom of the sketch is an expression of assurance, which comes with practice.

To follow this instruction, it is essential to be aware that to draw is to draw an object, and without knowing this object – the kind of shape, material, and its various uses - it is difficult to draw. The objects in this book are those of our everyday surroundings, derived from industrial production, either architectural subjects or those of the urban landscape. These subjects/objects are governed by regular lines of construction, and perspective itself is almost governed by the presence of these regular lines.

Finally, you have to understand that drawing is a language, and that as such it cannot be understood without using imitation at the beginning: you learn a lot about drawing by looking at drawings.

## Drawing by hand

In this book, we encourage you to practise drawing freehand regularly, and sometimes using a ruler and a rubber.

So long as you don't feel the need, don't use a ruler or a rubber, in order to give yourself practice. A too careful drawing loses spontaneity. The best advice I can give you is to try hard to draw accurately and not worry too much about little mistakes.

## Observation drawing and imaginative drawing

Observation drawing allows the draughtsman to reproduce reality, and is often used by travellers. All the work here consists of reproducing what we can see; it can be compared to a photograph. The imaginative drawing is that of a concept. It can range from a preparatory sketch for a film-maker, to that of an object, or an assortment of elements, in order to appreciate their potential. It is the drawing of the designer, the architect or the landscape painter, obliged to dream up a concept for an object, its makeup, to put it in perspective and to define its final appearance.

In the latter case the mental processes are obviously more numerous. These two kinds of drawing are very different, but it is a formative experience to recognise that in the end the two

approaches are complementary. The imaginative drawing, through the knowledge of geometry and perspective that it assumes, is a valuable training for reproducing what you see in an observation drawing.

## The framed drawing

The framed drawing corresponds to the choice we would make with a camera: from the inside of a window, cutting off the visual field, everything is seen and reproduced. The painter also works in this way. This choice implies a certain way of understanding the drawing (see p.78). One can think of the window of vision as something level, and totally ignore the depth. It is enough to put down accurately the various elements, the lines of construction, the outlines and the values, so that ideally they are projected onto a transparent plane interposed between them and us.

## Drawing the interior and the exterior

When we make an observation drawing, we have the feeling we are drawing an object from the outside. On the other hand, if we want to do an imaginative drawing – a piece of furniture for instance – we think first of all of its composition, its function, then the eventual variations to get progressively a view of its organisation. The view here is the result of an operation of construction.

The frame is not necessary. The object appears as an isolated form on the paper.

The internal work can be felt in the final expression of the form, but also in the production and visual achievement of the drawing.

In this book we will combine these different approaches, observational and imaginative, interior and exterior, well framed or an isolated form, as complementary registers that have to be worked conjointly, for it is important to understand the structure of the things that we observe, and to give an appearance of reality to the fruits of our imagination.

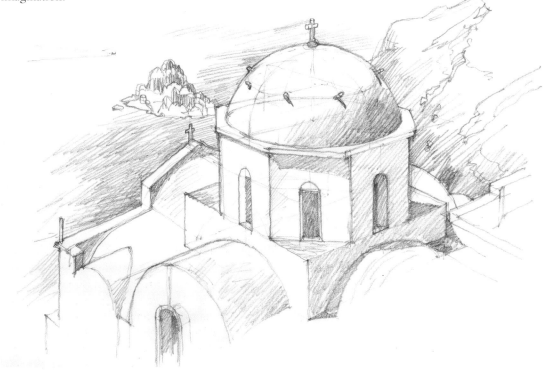

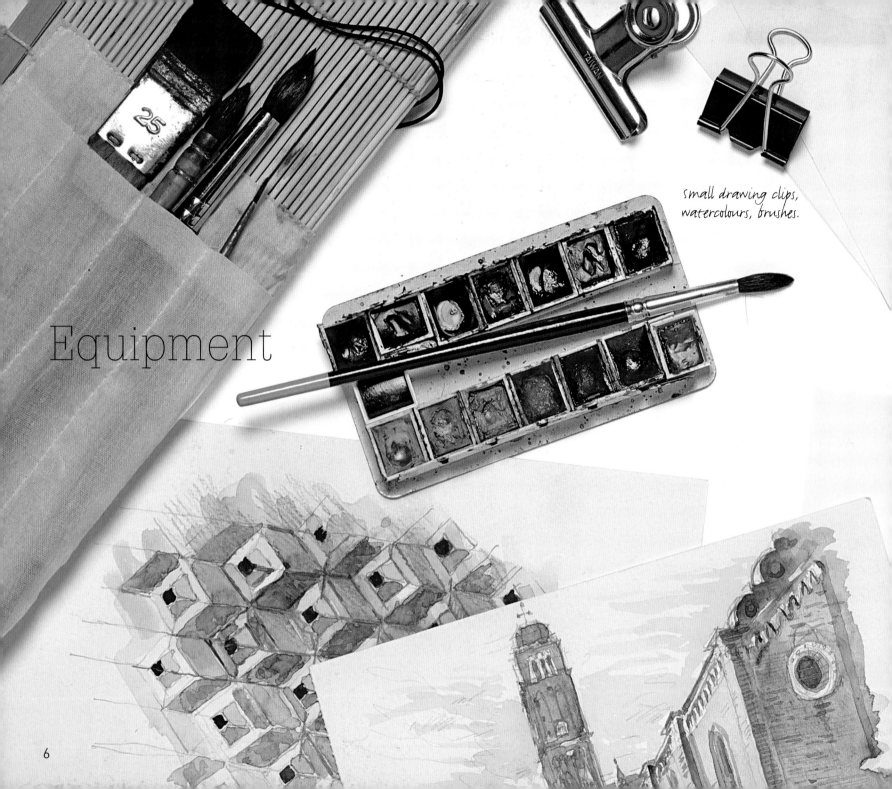

# Equipment

small drawing clips,
watercolours, brushes.

Typing paper, sketchbooks.

Almost all the drawings shown here are done
with a propelling pencil, size 0.9 or 0.5.
HB or 2 B [pencils] are most used.

Ruler, Kutch scale, setsquare.

# THE STROKE AND THE LINE

As with the sound of a musical instrument, the the line, or stroke of a drawing is the most sensitive dimension and the one that gives most pleasure. The quality of the line is the essential key to progress, encouraged by a pleasure in drawing.

## The stroke

The line is an indication of a gesture, an attitude, and at the same time a reflection of the personality. Its good points and bad points are therefore in the image of the person who drew it: direct, straightforward, clumsy, hesitant, heavy, light, long-winded, incisive.

The quality of the line is acquired by practice, so we invite you to do some warming-up exercises and experiments. The pleasure you will find in the sensual perception of the line will support your intention to draw. And equally, if you draw with enthusiasm and spirit, that will show, and will arouse interest in your drawings.

In any case, we urge you to observe carefully the drawings of artists that you like or that you feel could be a model for you.

## Different kinds of stroke

If you draw on rough paper to then trace off and refine the result, you have a spontaneous line, free, assertive and a little thick. The final traced line will be simpler and clearer. The effect is quite different if you work directly onto paper, as in an outdoor sketch. Paradoxically, it is often the finished line which is most uninteresting and flat… you have to think about that: to see the work and its traces is a pleasure for the person looking at it.

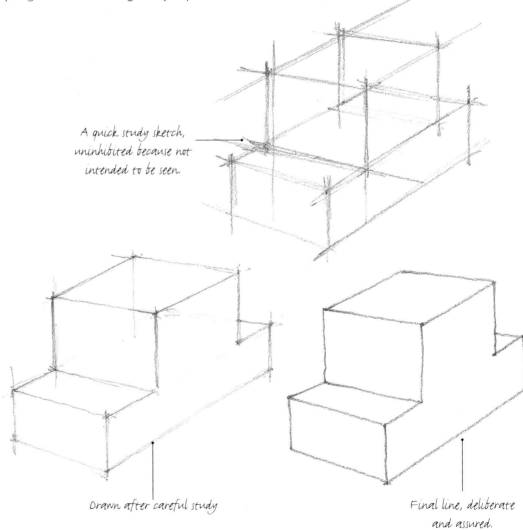

A quick study sketch, uninhibited because not intended to be seen.

Drawn after careful study

Final line, deliberate and assured.

8

## Graphics, values

The pencil draws lines; it isn't made for covering surfaces like the paintbrush but it can show them, as well as the shadows that give body.

Practice drawing greys, made of hatchings or points, of different but even strengths, starting with even ones, then practice doing gradations.

Study the effects of the spacing of the lines: a grey made of thin, close lines can have the same tone value as another made of thicker lines, more spaced out. However, the luminosity is not the same. The regularity of the hatchings that make the grey is also a factor: it is easier to make small lines that intersect, but they must stay regular without becoming rigid and mechanical

## The line

By line I mean the stroke when it is not just read as a graphic or plastic element, but as a signifier, a motif, axis, contour, or the outline of a volume. It is still a trace, but some different qualities come into play. The essential is to learn to draw straight lines by hand.

You can try different methods: the first consists of drawing very fine preliminary lines, and then going over them with one stroke, or progressively, watching out for differences in the strength of the stroke. The second method consists of drawing fine lines superimposed on each other and leaving them in place, like a light local mist. The next level after mastering the line is the construction of figures, especially circles, which we will see on p.17.

Practise drawing assured lines: mark two points, then leave one to go directly to the other. Look at where you want to go rather than the point of your pencil. Make the trace twice, the first time without touching the paper.

Practise also controlling direction. Start with the horizontal and the vertical, then continue with oblique ones, mentally noting the angles formed.

Draw some horizontal lines, then vertical ones, more and more close together. To do this, draw two parallel lines a short distance apart, then gradually fill in the space, making first a line in the middle, then again in the middle and so on, the lines becoming closer and closer.

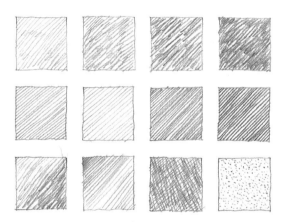

In general, the greys obtained by using the white of the paper between the lines are lighter. You must avoid 'blocking' the greys with continuous matter. Multiply the tries at screens, cross-hatching, stippling and other effects.

studying the greys and the screens is a good method of approaching the question of the quality of the stroke.

9

# Proportions

The first element to master, in order to draw, is the idea of proportion. This is not a question of aesthetics, as in knowing if the proportions of an object are pleasing or not, but of correctly reproducing the proportions of an object in the drawing.

We always use a small length to measure a larger one. This avoids complicated calculations.

### How to measure proportion

These measurements are made directly by eye, or with a pencil used as a measuring tool.

1    Hold the arm with the pencil in front of you, visually superimposed on part of the subject, the height of the roof for instance.

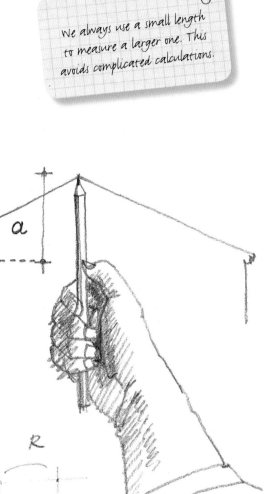

2    With your thumb as a cursor, mark the small distance a between the point of the pencil and the thumb. This length in itself has no connection with the original, nor with the same length in the drawing, but it will serve as a unit of measurement. It marks the opening of the angle of vision by which you see the top of the roof.

3    Keeping your thumb in the same place on the pencil, move your pencil to another part of the model. Count how many times 'a' goes into this new length, sliding the pencil along as many times as it takes, here three times, then the remainder R which we estimate at about half. We note the ratio of 3.5 between the length and the height. But be careful: you must not change the distance of the eyes and the pencil between the two measurements or the ratio will be wrong.

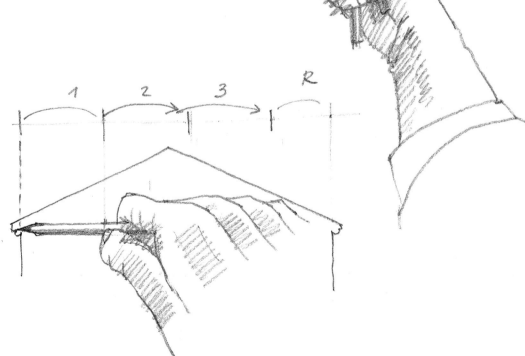

10

## Transferring the proportion to the drawing

First draw one of the lengths, preferably the smallest. To give the proportion, you must start from this length in the drawing and transfer it three times, then a half, using a pencil or making little marks along the direction wanted. You arrive at the desired length.

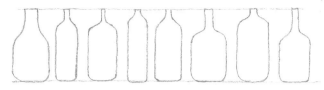

*In this series of bottles, note how the same shape takes on a completely different significance with each change of the proportions.*

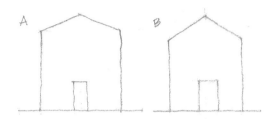

*Example of drawing B from the original A. We see that not observing the proportions means that the character of the model is lost, resulting in a banal version.*

## How to find the correct proportions

The drawing does not have the dimensions of the model, and the only formal similarity is in the exact proportions. Experience shows that beginners make gross errors in proportion. Even more experienced draughtsmen are not totally without errors. Just be aware that a drawing where the proportions were completely exact would be almost perfect.

In fact, what you must measure is not the real height of the object, for example the true 30cm of the bottle, but rather the angle at which this object appears to us. Moreover, we don't even measure the angle, but only the ratio between two angles: here, the ratio between the angle at which the diameter appears and that at which the height appears.

Finally, note that through the angles there are lengths apparent which are measured, because the effects of perspective modify the ratios between the real lengths. This corresponds well with what the eye sees in perspective.

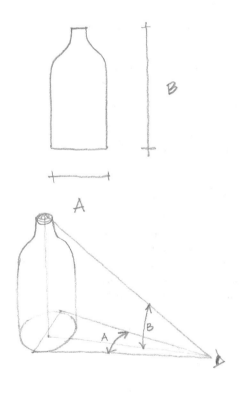

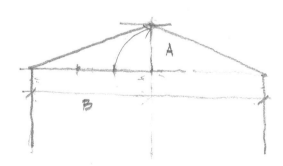

*If you measure that the roof is six times wider than the height, it means that the ratio between the two angles under which the two lengths appear is 6.*

*Don't confuse the proportions of a subject in reality and seen in perspective, really flat as they will be on paper. Two points far apart can be found very near in the drawing.*

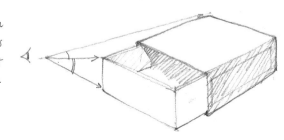

11

# Division

The method of using diagonals allows you also to divide a rectangle.

When drawing, you frequently have to make simple divisions of length. Most often we use a line or a rectangle connected with it, using the intersections of diagonals. This method (like that of Thales's theorem, opposite) also works in perspective, the rectangle being transformed into a trapeze and the two 'horizontals' being the vanishing points (see the chapters on perspective, p.58).

### How to proceed

For simple division into two or three, it is best to start 'by eye'. For successive divisions you can then also divide by four (2x2), six (2x3), eight, twelve, etc. so long as they are multiples of two or three. We can use the methods illustrated opposite, which are a mixture of judging by eye and a little reasoning. For dividing up to 12, it is enough. In fact, we rarely have occasion to divide by more than five but amusing yourself with division is good training for the eye.

### Divide by 2

The division of a line is done by eye.

The division of a rectangle is done by eye, then by diagonals.

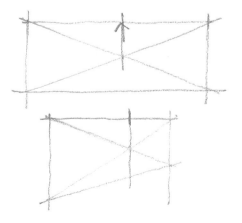

### Divide by 3

The division of a line is done by eye

The division of a rectangle is done by eye or by the rule of the diagonals.

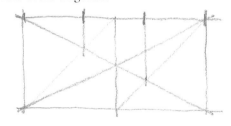

### Divide by 4

Two times by two.

## Divide by 5

The division of a line is done by eye, in two steps. Mark a central space, judging that the two remaining spaces are double that space. That is fairly easy. Then cut these remaining spaces in two.

## Divide by 6

Divide in three, then in two (or the other way about, but it is easier to start with the smaller intervals by eye).

## Divide by 7

Use the same principles as when dividing by five: a central space, then the sides divided into three.

## Divide by 8

Into two, three times

## Divide by 9

Into three, three times

## Divide by 10

Into five, then each segment into two

## Dividing by 11

This case is rare. The method used is the Theorem of Thales.

## Division using the Theorem of Thales

We want to cut a length AB into equal parts (five in our example).

Draw a half-straight auxiliary Ax, beginning at A and with an indefinite length (the angle is immaterial). On Ax, beginning at A, we mark a small segment 'a'. We then mark 'a' five times along Ax, obtaining the point C. We then draw CB, then lines parallel to CB for each segment, as shown in the diagram. The result gives the required division. We have thus replaced division with a series of additions and drawing parallel lines. In this way we can divide any segment into any number of equal parts. The bigger the number, the more the construction is interesting.

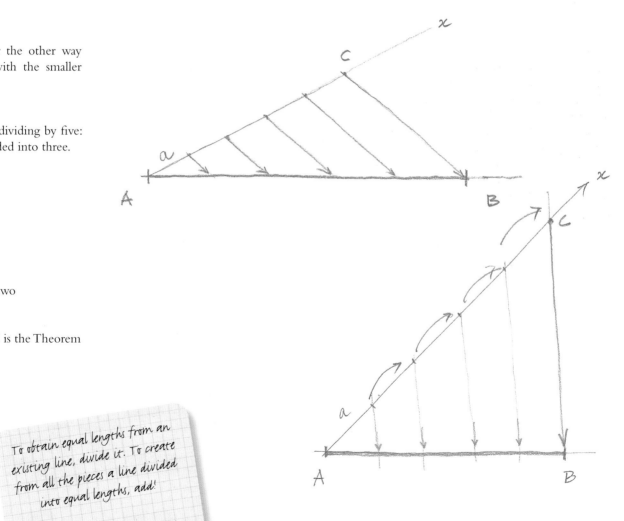

To obtain equal lengths from an existing line, divide it. To create from all the pieces a line divided into equal lengths, add!

# LOOKING FACE ON

If the drawing seems mainly to show objects in a space, it is, however, essential to have a good basis for showing the 'world face on'. Face on implies that it is a question of an object in two dimensions on a ground plan, like a plane figure or a letter of the alphabet. This also applies to any subject already imprinted on a support.

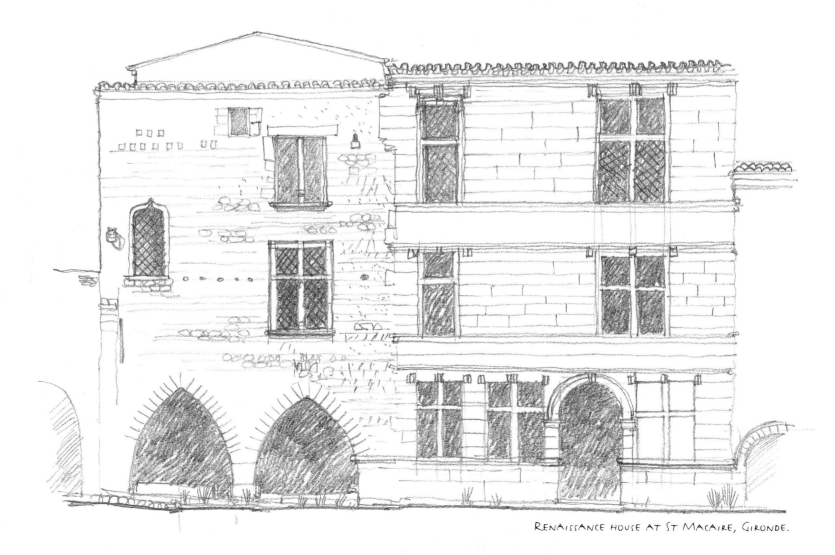

RENAISSANCE HOUSE AT ST MACAIRE, GIRONDE.

# The basic figures

The square is the basis of all construction. It is a kind of visual tuning fork, which brings together the vertical and the horizontal, and introduces the 45° angle.
The circle is the second essential figure, together with the square, to which it is obviously linked.

### The square

We frequently need to sketch a square, even mentally, to verify a measurement. Practise drawing this shape as often as possible, dividing it, filling it with a square pattern and with various shapes, square or not.

*Also practise drawing squares at an angle: you will find this useful for isometric perspective (see p.32).*

## The circle

If this exercise is a little tricky like the square, it is indispensable. Practise drawing bigger and bigger circles.

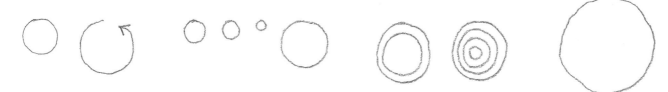

When the size of the circle becomes bigger, you have to use construction lines. The two axes, vertical and horizontal, drawn to the same length, are the main help. Draw the circle round the segments tangents, which mark the ends of the axes.

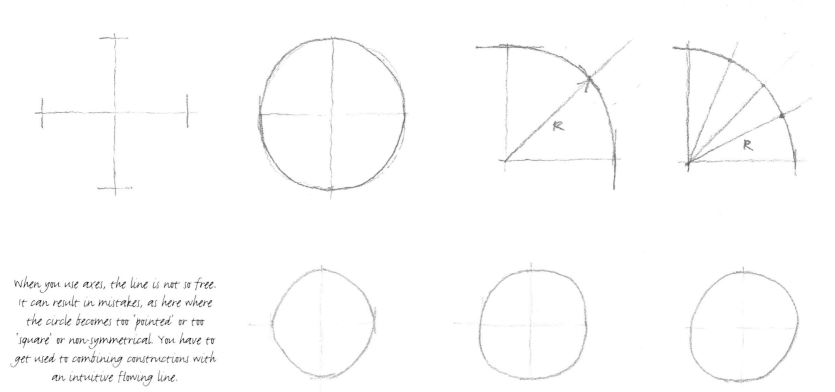

When you use axes, the line is not so free. It can result in mistakes, as here where the circle becomes too 'pointed' or too 'square' or non-symmetrical. You have to get used to combining constructions with an intuitive flowing line.

## Some construction tricks

To check where a circle goes through the diagonal, look at this little construction made in a quarter circle. The little square in the top angle is a quarter of the base square. Point A marks the centre of this little square. The circle therefore passes OA a little below.

Here is another construction giving a remarkable point on the passage of the circle. We know that the points on a semi-circle form a right angle with the ends of the diameter AD. Moreover, the construction relies on the intersection of the diagonals AB and CD, C being the middle of FB. The intersection of these lines makes a right angle. In effect, the two triangles ABD and DCB are similar and turn 90° one in relation to the other. We deduce from this that point E is on the circle.

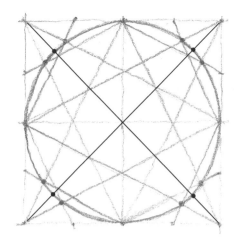

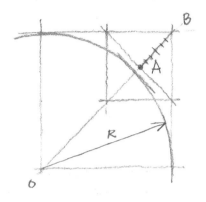

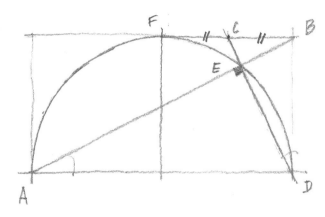

We can repeat this construction in a circle eight times. Thus in total you have 4 (the ends of the axes) + 4 (the points at 45°) + 8 points make 16 identifiable points.

THE QUARTER CIRCLE: A REPERTOIRE OF THE MAIN ANGLES
The quarter circle serves to make the angles 15°, 30°, 60°, and 45° with the diagonals of the square in which it is drawn. Note that the 30° angle cuts the circle at its mid-height.

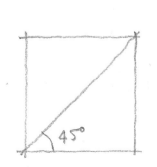

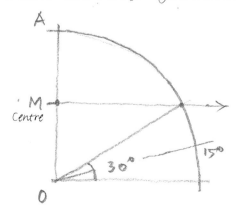

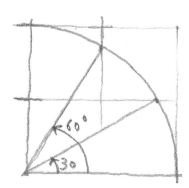

### Ellipses and curves

It is useful to have at your disposal a range of construction tricks, especially ellipses – circles seen in perspective – which are often found in our surroundings.

### Drawing an ellipse

Draw any parallelogram. Divide the sides by two and draw the axes: you then obtain four supports (four tangents) for the ellipse.

### Drawing curves

Here is a trick for drawing regular sinuous curves. Assign these curves to the portions of the circles that follow each other; their centres $O^1$ and $O^2$ and the point of contact T are always aligned. Note however that not all regular curves are necessarily constructed on a circle – this is the case with parabolas, for example.

Even if you don't have to construct such figures rigorously, it is useful to know this rule when you are drawing and want to control some linked curves.

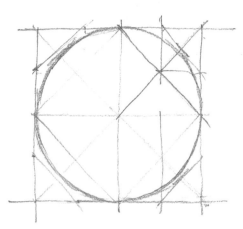

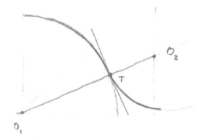

*The ellipse is like a flattened circle. To draw it, use the points of the half diagonals.*

*This rule applies equally to curves in a spiral.*

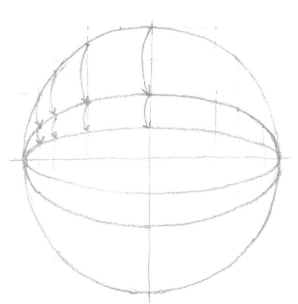

*In perspective, a circle looks like an ellipse.*

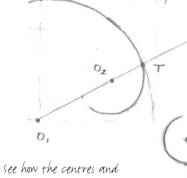

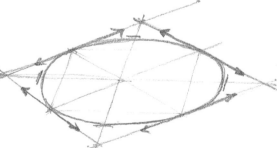

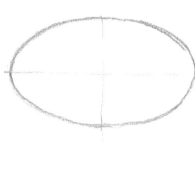

*see how the centres and points of contact succeed each other in a sinuous line based on the circles.*

# Borders

Drawing borders or frames is a very useful exercise for drawing furniture (furniture with drawers, cupboards with doors), facades and windows. It is an excellent synthesis of drawing rectangles and of proportions.

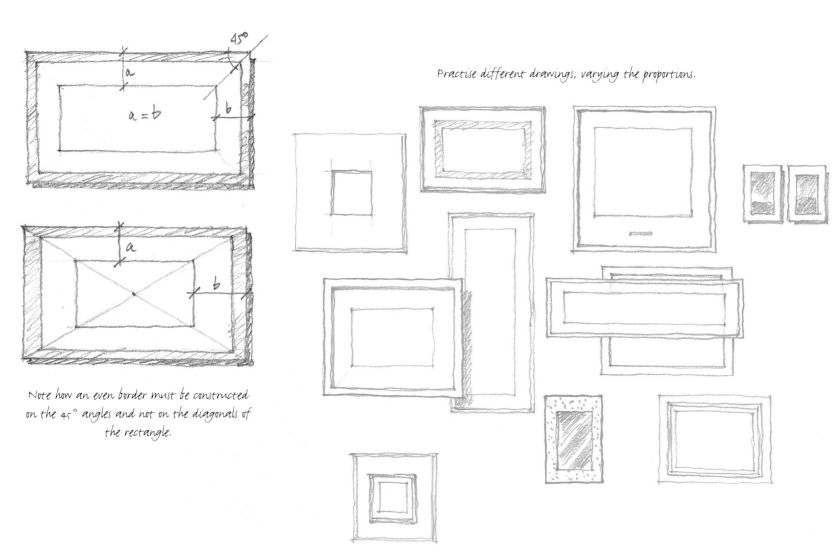

Practise different drawings, varying the proportions.

Note how an even border must be constructed on the 45° angles and not on the diagonals of the rectangle.

In the same spirit, draw free or geometric shapes, repeating the motifs;
this is what I call 'paper carpets'.

# Drawing letters

Letters are familiar flat objects that we are always coming into contact with; they are complex and skilful, at the same time technical and artistic. Without going into real typography, which is a very organised art, it is a question of observing some principles and geometric effects present in all made objects.

### Drawing individual letters

Practising drawing letters is an excellent training in drawing, apart from the difficulties of perspective. Start by observing the rules of construction for letters in the different alphabets; find the main structures.

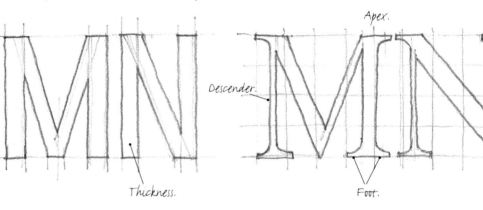

Apex.

Descender.

Thickness.

Foot.

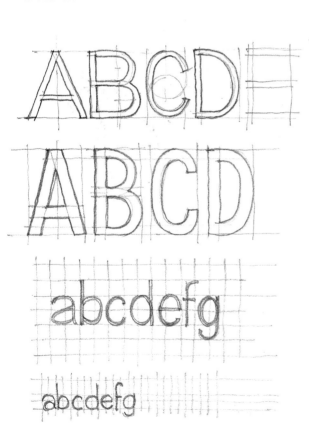

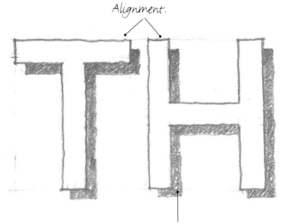

Alignment.

Draw the cast shadow. It's a good start for making shadows which we will see on p.43.

## Drawing letters by dividing up a panel

Letters, always in groups, are an excellent subject for practising grouping in a specific area, like the windows on a façade, or the cars in a car park. In fact you have to learn how to manage the space: that of the billboard, the space between each letter, and the space at the ends of the line. Look at the examples, then make up your own text.

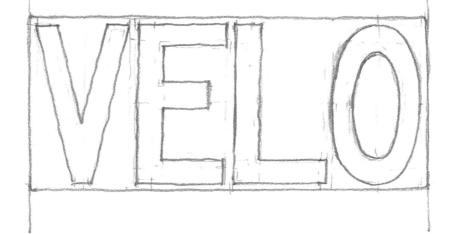

Stockholm

alibaba

Lilliputt

DIVISION

DIVISION

Belleville

Lollypop

VELO

# Drawing objects seen face on

It is the basis of the drawing known as 'geometric', such as industrial design, or architectural drawing. This 'flat' drawing consists of showing objects face on, without perspective, like the front of a house. Choose small objects like a pencil, a mobile phone, a calculator or a bottle. These industrial objects, carefully put together, will familiarise you with proportions, shapes, axes and thickness, which later you must master in perspective.

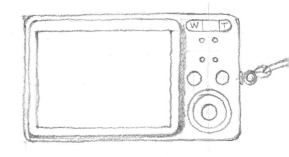

Frames, rounding off, main shape and secondary axis around which symmetry is organised.

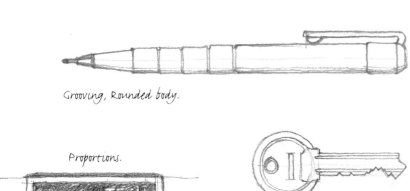

Grooving, Rounded body.

Proportions.

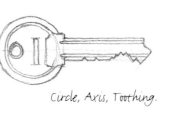

Circle, Axis, Toothing.

Circular objects, with motifs which are distorted by a flat projection. In one of them volume is shown by shadows.

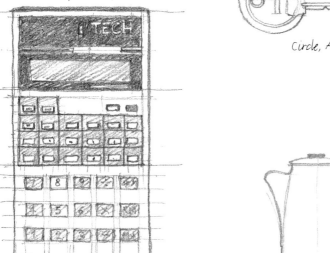

24

## Drawing furniture

By increasing the dimension of the subject, you can show furniture.

Analyse the shapes from the logic of their construction. You will see that we can incorporate them into recurrent groupings of simple shapes. An essential aspect of drawing is to understand how an object is made: drawing, as we understand it here, has a direct relationship with what we know about an object.

Geometry.

Thickness.

shapes.

Materials.

View face on.

seen in profile.

25

# Drawing windows and façades

Drawing a window enables us to make some new observations. This a simple object, essentially repetitive, and only consists of rectangles fitted together. But the accumulation of the subdivisions brings distortion to the proportions (see drawing borders, p.20).

All the rectangles that have the same diagonal have the same proportions; they are homothetic. In the same way, all the rectangles whose diagonals are parallel are homothetic.

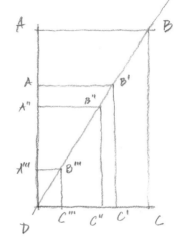

**Drawing windows**

The diagonals that are not parallel show that the rectangles fitted together don't have the same proportions. This is the difficulty to be overcome when drawing a window or a façade.

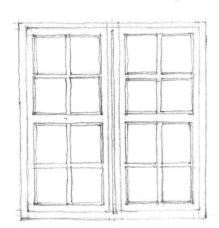

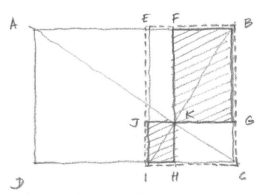

If you turn a rectangle through 90° around O, you have a second rectangle with the perpendicular diagonals of the first.

In the same way, if two rectangles have perpendicular diagonals, they have the same proportions. They are homothetic.

The rectangles FBGK, JKHI, in grey, and EBCI, dotted, are all homothetics of the large base rectangle ABCD.

## Drawing façades

Drawing the façade of a house or a small building shows well the different principles shown. The complexity is only apparent: there is a hierarchy of things fitted together, little systems of reference with axes, proportions, grades of thickness. According to the style, the correspondences and the hierarchies are more or less strict: some, as in the houses of Saint Macaire, have independent subsets.

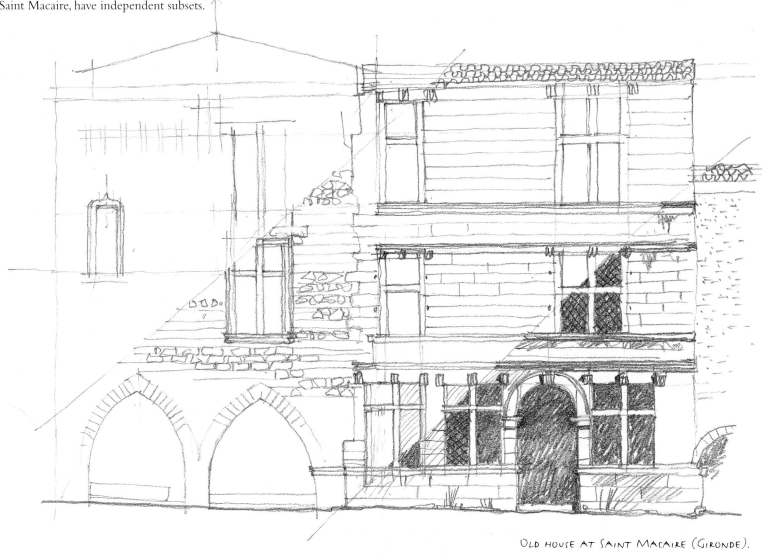

OLD HOUSE AT SAINT MACAIRE (GIRONDE).

27

# Geometric drawing

Before tackling perspective, it is useful to make a quick detour via the most classic method of showing volume without leaving geometric mode: flat drawing, the basis of industrial design or architecture.

One of the principles of geometric drawing, based on descriptive geometry, is to combine several complementary drawings (we 'see' face on, profiles, plans etc).

### Why geometric drawing?

This method allows you to keep the same dimensions in a drawing, to use a scale and to take measurements directly. It is thus widely used, notably in building. But it is not the most expressive way to show volume. And it is to remedy these insufficiencies that we use different kinds of sketches and perspectives.

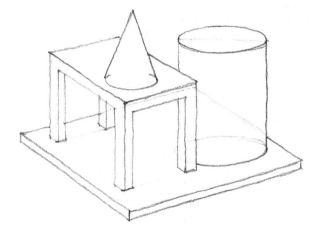

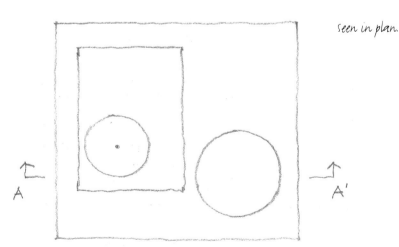

seen in plan.

This is the plan seen from above. The feet of the table are not seen.

This is a section on plan. In effect, the various elements have been cut off horizontally to show the elements under the top (the feet). The thick lines indicate what has been cut.

# Different cross-section views

They correspond to what is above the vertical plan, indicated on the plan by little arrows that indicate the direction. The cut pieces are also indicated here by a thick line.

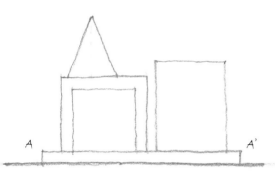

Geometric view face on.

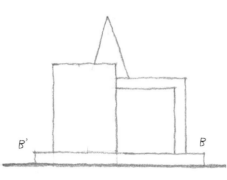

Geometric side view.

View face on with shadows.

Cross-section view. As well as being able to cut elements horizontally, we can cut vertically to show parts that are hidden in elevation.

In this cross-section the left base of the table appears, while it is hidden by the cylinder in the elevation above.

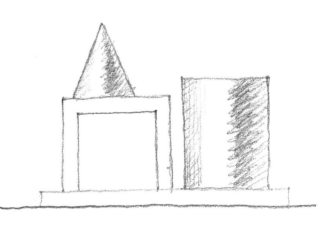

Side view with shadows.

# ISOMETRIC PERSPECTIVE

Isometric perspective, also called Chinese perspective because we come across it in traditional oriental painting, or again axonometry, constitutes the beginning of perspective. It shows volume and space while being less complex than classic perspective.

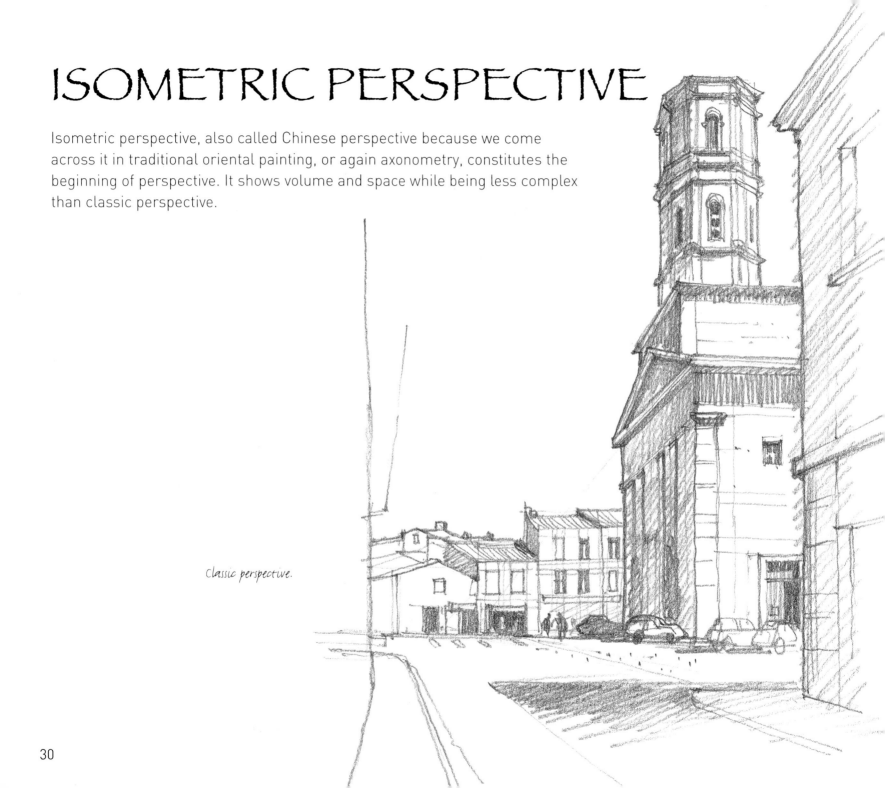

Classic perspective.

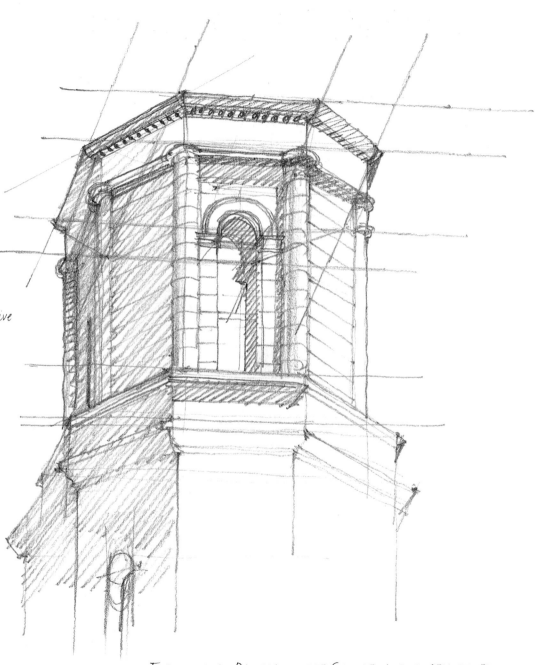

Detail of the bell-tower, extract from the perspective
opposite, drawn in isometric perspective.

The church at Pauillac in the Gironde, and its bell-tower.

# Principle of isometric perspective

This is a simple construction, based on parallel vanishing lines. This is due to the fact that the vanishing point is very far off in relation to the drawing, and the angle of the vanishing lines almost imperceptible. This is often the case with the details of an ensemble and because of this fact, it is a usual way of drawing small objects.

## Extrusion and isometric perspective

'Extrusion' is a term that has become fashionable in software model making. The two processes, isometric perspective for the visualisation, extrusion for the modelling (construction in volume) operate a little on the same principle. You start with a ground plan and you raise vertical lines that constitute the extent of the volume.

## Expression with shadows

The same volume at the start, here a simple cube, can be interpreted in various ways according to its own shadows and the shadows it casts.

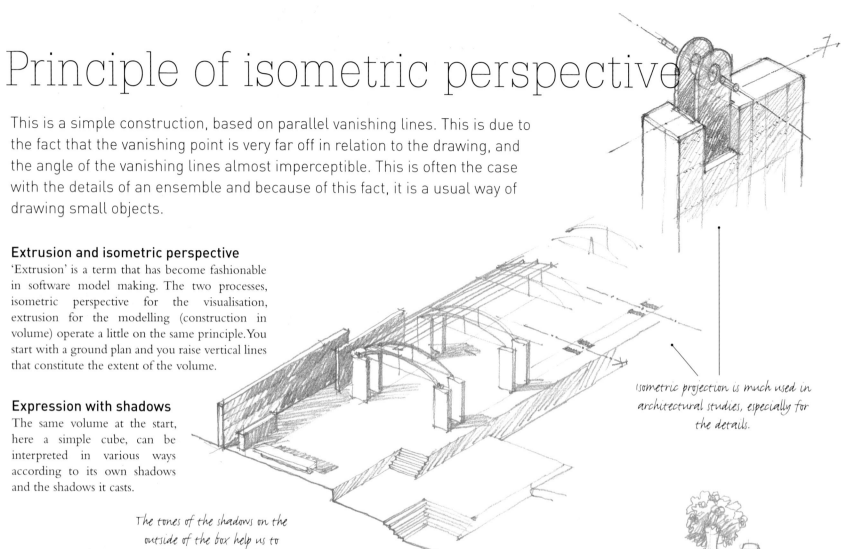

Isometric projection is much used in architectural studies, especially for the details.

Here is a cube, or a box, in isometric perspective.

The tones of the shadows on the outside of the box help us to see this volume as a cube seen from above and standing on a flat surface.

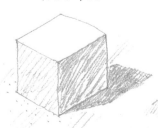

Here, the volume is seen as a hollow cube, situated above us. It is only the position of the shadow above that leads to this view.

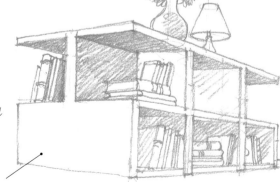

## A transparent construction

The different stages below show us how to think of isometric perspective, not as an opaque volume, imagined from the outside, but as a transparent construction built from the ground plan up.

*This method enables us to combine volumes. The base plan is a reference point for building higher.*

*The top surfaces are always lighter than the vertical ones, even in the sun. This is why the left vertical faces don't stand out, so that the top will be in the light.*

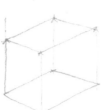

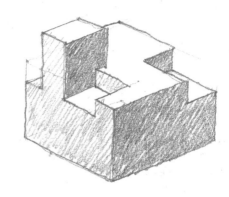

*By convention, the light comes from on high, from behind or from the left of the observer. This is what gives the shadows observed here (see 'shadows', p.42)*

## Variations on the principles of construction

The isometric construction enables us to adapt the drawing as wanted.

*Cube seen from above. A distinctive feature is visible, but the flat drawing does not allow us to interpret it.*

*Only a three-dimensional view like the isometric perspective enables us to understand what it is (it could have been a change to the elevation).*

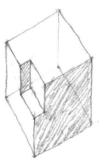

*The first principle of the construction consists of making a rotation of the floor plan. The angle of this rotation can vary.*

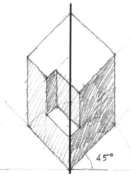

*The 45° angle has the fault of creating symmetry, so it is seldom used.*

45°

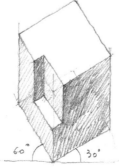

*An angle of 30°/60° is more common and allows a good view of both faces.*

60°    30°

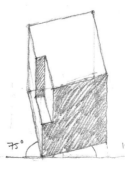

*Observe the angle: if the angle on the right diminishes (15°/75°) that allows a better view of the right-hand face.*

75°    15°

33

# Emphasising and optical corrections

Isometric perspective allows different adaptations to be made to the final drawing. It also allows for the partial conservation of the dimensions. This is why it is the preferred method in technical drawing.

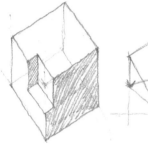 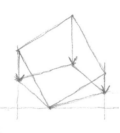

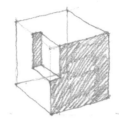 *Here we have divided the distance from each summit to the base line by half.*

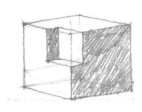 *This distortion is more exaggerated.*

## Variations in isometric projections of the cube

We can make another variation which consists of distorting the ground plan after having turned it, and before putting up the sides. Above, we have divided by half the distance from each summit to the bottom line. This results in flattening the volume, offering a more horizontal view showing the vertical faces more than the top.

## The optical correction

When we look at the drawings opposite, there is an awkward optical illusion: the cube seems to be unnaturally tall, even though the tops have the same lengths of the sides. It is because we think we are seeing a perspective, and in a correctly applied perspective there would be a flattening of the height. Our brain tells us that we are looking at a block taller than a cube. To get rid of this phenomenon we have to make a little correction, according to the same coefficient, calculated or by eye, which will artificially reduce the height.

*The lengths parallel to the horizontal sides are kept.*

*The height is corrected.*

## Keeping the dimensions

The isometric perspective has this in common with the geometric one: it allows us to keep some dimensions and their proportions. In general it is the lengths parallel to the horizontal sides that are kept. The heights have to be corrected (as shown left). The other measurements, notably the diagonals, are in general distorted, lengthened or shortened.

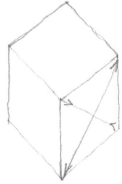 *The diagonals are distorted.*

## Emphasising the façade

We are no longer starting from the ground plan but from the façade. Here the ground plan is distorted and the face is frontal. This kind of view is designed to show a volume in a less objective way, more familiar than on a ground plan, approaching the view of a pedestrian.

If we make the sides equal as shown below, the cube appears to be at least one and a half times deeper. We have to correct the depth. This distortion shocks us all the more because this view (from the front) is more familiar than that from below (leaving from the ground plan).

The right side appears longer, but it is the same size as the others.

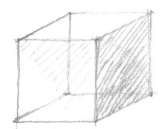

A coefficient has been adopted instinctively.

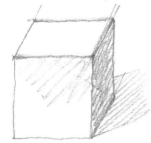

This variation reconciles the façade and the view from below.

The frontal isometric perspective is obviously well adapted to study a detail of a façade seen from below, or in three-quarters view.

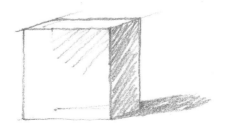

The effect of correction has been more increased. The side and top faces have become very narrow.

## Suggesting perspective

In axonometry the sides are parallel by definition. But a sketch is free, and will never be so precise as to seem to give exact measurements. All the same, we can give a little more realism to perception, by introducing a slight convergence of the lines to the back to give an effect of perspective.

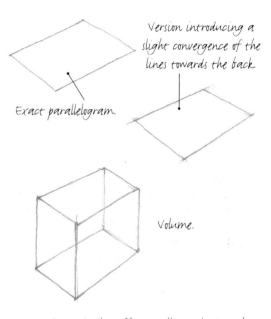

Version introducing a slight convergence of the lines towards the back.

Exact parallelogram.

Volume.

You can give a similar effect to ellipses playing the role of circles, drawing them a little wider so that they move away from the horizontal axis.

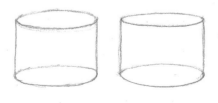

# Drawing small objects

For the same reasons as with drawing on the flat, drawing in isometric perspective is an easy exercise with familiar objects. It is most worthwhile, as it compares our knowedge and visual memory of an object with its graphic transcription onto the page.

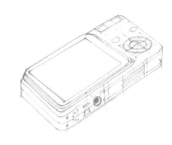

### Practise with familiar objects

We have seen that isometric perspective, by the use of parallel vanishing lines, is close to real perspective for objects occupying a small part of the visual field, or for things seen in detail. It allows us a very realistic result with small objects, such as a key, a battery charger or a camera.

*Break down the object into geometric shapes to get used to how it is constructed. This entails first analysing and 'deconstructing' the object.*

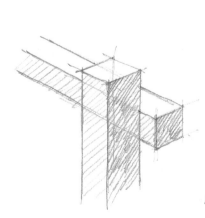

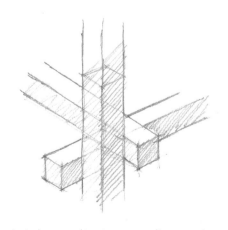

*Detail of the assembly of Red and blue armchair.*

### Drawing furniture

Pieces of furniture are often the most simple and 'constructive' because they need a stability which imposes an equilibrium and a geometric regularity of shape. Discovering the underlying geometric forms is moreover one of the main interests of this exercise.

Many architects have designed furniture and it is easy to find examples, like those shown here, around you or in books. The first is the famous Red and blue armchair, by Gerrit Rietveld. It is a good example for an exercise, first drawing the general outlines in thin lines (without thickness) then developing the thickness. You can tackle these with small detailed drawings.

The little stool was designed by Alvar Aalto in the 1930s, and if it seems ordinary nowadays, its geometry conceals nevertheless some difficulties. Notice that the plan is circular, but divided into three segments of 120°, and that we are far from drawing the circle in the square (see p.18). We have to find a simple way of drawing this angle, and to do that a little study on the flat is needed.

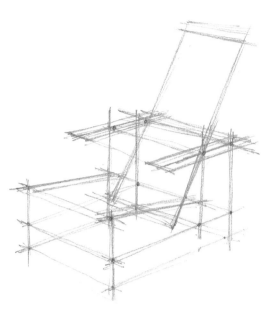

## Division of a circle into three equal angles

The three angles totalling 360°, each one must be 120°. Draw first a quarter of the circle, forming the angle AOB of 90°. Then next to it put in a third of a quarter of the circle, AOC. To do that, divide the second quarter of the circle in three (90° divided by 3 = 30°). The total makes 90° + 30° = 120°.

You could easily apply this little construction in isometric perspective and obtain the beginning of the stool. Then methodically draw the circles and the divisions. The difficulty lies in taking account of the thickness of the main lines.

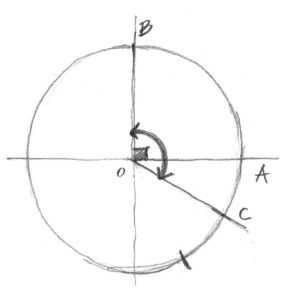

Drawing and analysing objects often involves research which is equally instructive as the drawing itself.

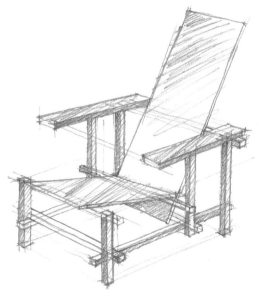

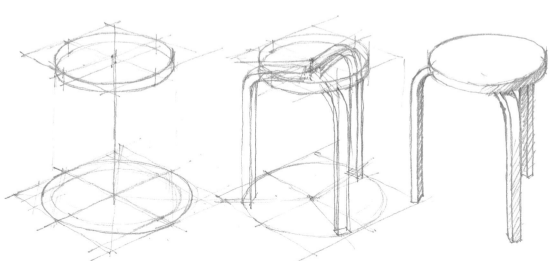

# Exercises in isometric perspective

Isometric perspective can be done with instruments – T-square, set-square, ruler – but our aim is for you to learn to construct freehand. So you must practise finding angles of vision that please you. It is not necessary to follow the measurements given to the letter, so long as the work stays coherent and readable.

## A common error to avoid

When you start an isometric perspective for a cube, make sure that the two summit points A and B are not on the same vertical line. It would result in awkward superimpositions, both for the structure and the clarity of the drawing. It is an easy mistake to make if you don't watch out.

## Working on the appearance

Take advantage of these tries to show the different kinds of appearance: transparent, opaque, with a strong contour line and different graphics for the shadows. Find a motif and repeat it regularly, leaving little variations.

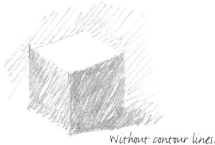

*Without contour lines.*

*Avoid placing the top points A and B on the same vertical.*

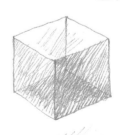

*Transparent.*

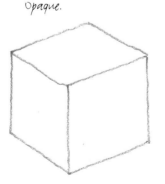

*Transparent.*

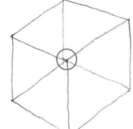

*Opaque.*

*Reinforced contour line.*

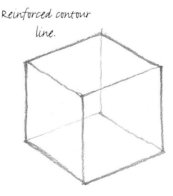

*Opaque.*

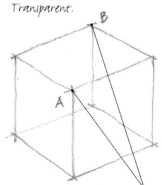

*Separate vertically the points A and B*

## Exercise 1: The Magicube

Construct a cube made of eight little cubes, but don't draw the eighth cube.

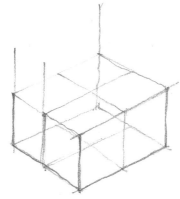

2 Put in the vertical lines, and the first layer of little cubes.

Don't hesitate to rough out a first sketch to keep an idea of the whole object

3 Go on to the second level, and proceed by adding some more elements. Watch the alignment of the lines and the points before drawing the lines heavily.

1 First draw the ground plan as for each time, dividing it into four according to the axes.

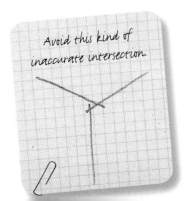

Avoid this kind of inaccurate intersection.

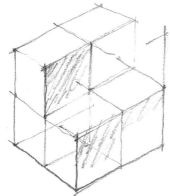

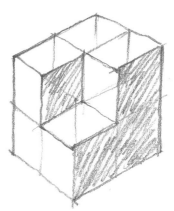

4 Finish the drawing, making sure that the edges intersect well, and defining the faces correctly. Finish any way you like.

## Exercise 2: Placing the depth of a hole

Make a square hole in the middle of a cube, depth half the side of the cube. You have to be able to see the bottom of this hole in the drawing to understand it.

This first try, using the same principles applied in Exercise 1, shows that this is not a good angle and we have to be more up above.

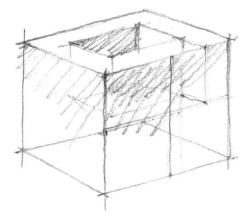

1    Turn the base square by about 30°. Put in the vertical lines. Place AB' = AB. Then bring down B' towards C to correct the height by eye, here about ¼ of the initial height.

2    Once the cube has been sketched, with the faces divided into four, draw the outline of the hole on the top face.

3    Then observe how we place the depth of the hole, following a path. Start from an angle at the edge of the hole A, join the edge of the cube B, go down the face of the cube BE to the middle, then go through the thickness of the cube to join A', the vertical coming down from A.

4    Starting from A' we can draw the bottom of the hole.

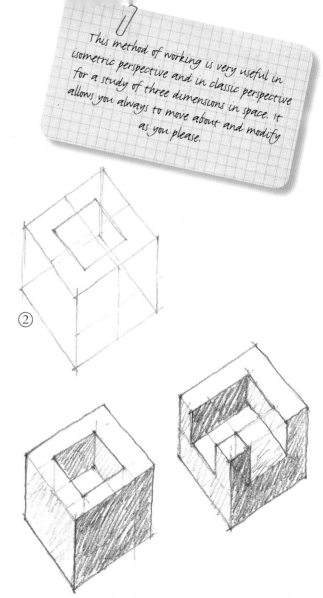

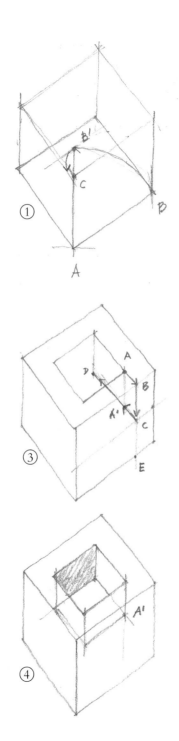

This method of working is very useful in isometric perspective and in classic perspective for a study of three dimensions in space. It allows you always to move about and modify as you please.

The object is finished. The lines of construction can stay underlying for any possible changes.

40

## Exercise 3: Drawing a straight flight of steps

Drawing a little flight of steps is an excellent training in drawing: drawing parallel lines, adding the risers, making the levels correspond, etc.

1 First mark the width of the steps on the layout.

2 Construct a vertical grille on which you can draw the outline of the steps.

3 Draw the steps and remove the construction marks.

4 Add the shadows.

## Drawing a staircase with a turn

The difficulty with this drawing in isometric perspective lies in mastering the numerous superimposed lines of construction.

1 Draw a flight of three steps, using the same method as in the preceding exercise. Make a start on the landing and the outline of the following flight of steps.

2 Continue with the body of the landing and second steps, drawing the horizontals parallel to the first flight of steps.

3 Finish the drawing of the whole construction.

4 Remove the construction lines and show the volume with shadowing.

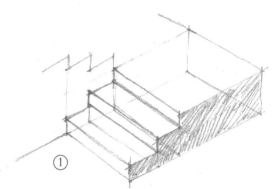
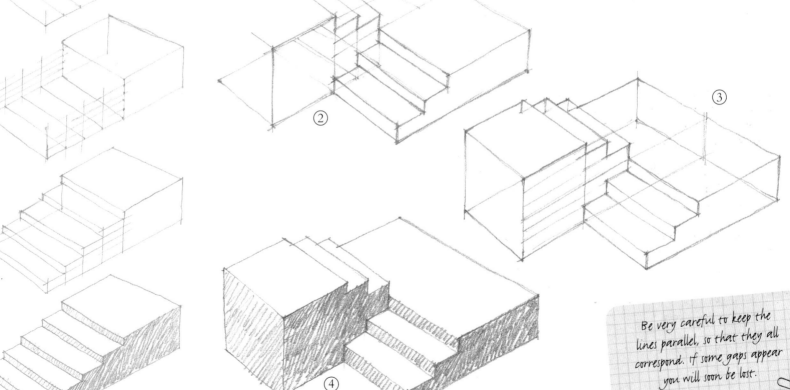

*Be very careful to keep the lines parallel, so that they all correspond. If some gaps appear you will soon be lost.*

41

# Shadows

To show body in geometric drawing, you have to show shadows. In isometric perspective, adding shadows makes the drawing more vivid.

## The basic principles

The shadows we are talking about don't correspond to the shadows cast on an object by the sun; they are a conventional way of showing body. The shadows linked to the movement of the sun, following the hours and the seasons, are easily shown with architectural software.

## Own shadow and cast shadow

The object's own shadow can be deduced logically, and doesn't need any particular construction. On the other hand the cast shadow is made geometrically. This is what we are going to study now.

## Parallel lighting, conical lighting

These are also known as sun shadow and torch shadow: the names are self-explanatory. In practice, we only use parallel lighting which is easier to construct and more descriptive, being more neutral.

1   The light rays are parallel, coming from a light source at an infinite distance, like the sun.

2   The light rays come from a source close by, and are diverging, forming a cone.

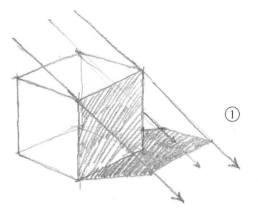

①

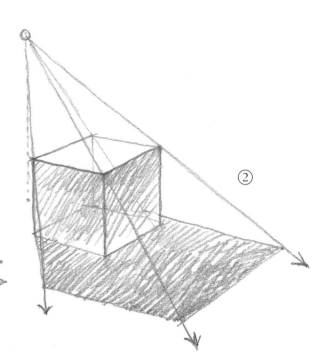

②

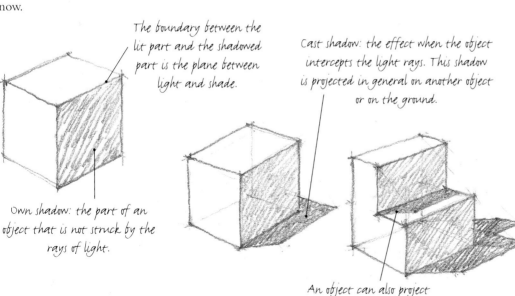

The boundary between the lit part and the shadowed part is the plane between light and shade.

Own shadow: the part of an object that is not struck by the rays of light.

Cast shadow: the effect when the object intercepts the light rays. This shadow is projected in general on another object or on the ground.

An object can also project shadows on itself.

## Constructing shadows

This construction is usually done by descriptive geometry, in geometrics. Here is how we can easily do it by isometric perspective, if we keep to simple indications on the sketch.

1   The sketch below shows the shadow from a flagpole. The direction of the light rays is given by the little vector D. But this direction is not enough to know where a ray touches the ground. The mast shows us that a direction D is associated with a direction BO, which is that of the flagpole's shadow, and more generally the direction of the shadow of a vertical object. The intersection of D and BO gives the shadow of A.

If we keep from this image the two vectors $D^1$ and $D^2$ we have a diagram showing, in isometric perspective, a direction of light in a space. Such a diagram will allow us later to make the shadow from any part of an object. By this very simple method we can construct point after point of complex shadows, as soon as we know the points and their height.

2   The drawing of a cast shadow is essentially the drawing of its contour. In sketch 2, opposite, note that this contour is none other than the plane between light and shade. The problem then comes down to making the shadow from all the points of the plane, starting with the noticeable points shown here.

## Exercise

The following exercise will show you how to go about it.

1   Draw a flagpole with its shadow, as in the preceding example.

2   Draw a second flagpole, behind the first, also with its shadow.

3   Hang a cord between the two poles. To make a drawing of the shadow, draw the light ray leaving from the point whose shadow you want, and find where it reaches the ground by drawing a line parallel to the shadow of the pole.

4   If a towel is hung on the cord, the shadow is made in the same way

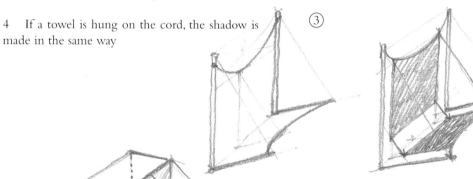

The contour can be easily deduced by copying the plane between light and shade along a vector parallel to the ray where it meets the ground.

① A

Vertical.

$D_1$

Direction of light ray.

$D_2$

O

B

Drawing of light ray.

②

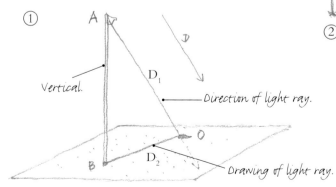

The drawing of a cast shadow is essentially the drawing of its contour. Note that this contour is none other than the plane between light and shade.

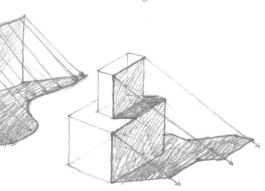

# A system for making shadows

There is a similarity in the extrusion that characterises the isometric projection and the shadow. In effect, it consists each time of a projection from a point object X towards a point image Y, following one direction and one length in this direction.

## The disposition of shadows

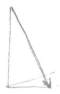 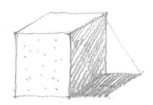

This ray of light must not be parallel to the faces because in that case the shadows are a prolongation of the faces, which is not very intelligible.

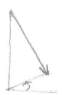 

It is better to orient it like this, making sure to avoid misplaced alignments: not always easy with so many directions.

When the ray of light is in front, all the faces seen are in the shade, the object is against the light.

## The shadow of a wall

The shadow of the wall is similar to the case of the towel hung on the line (see p.43). If the wall is cut out, the shadow 'falls', the little piece C'D' corresponding to the vertical cut-out CD. It is parallel to AB' and to FE'.

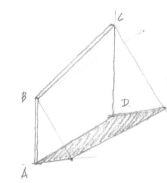

If the top of the wall is on a slope, it is enough to join up with a straight line the shadows of the angles B and C.

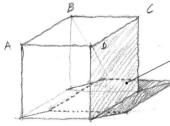

The shadow of a horizontal surface, here the bottom of the box, is the tracing of this surface, projected on the ground.

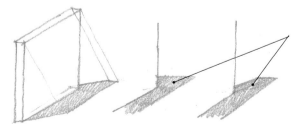

Note that we can find out the thickness of the wall from the simple detail of its shadow.

## The shadow on a wall

The ground is not always regular, and the obstacles which appear are equally occasions for complicating the shadows.

*In this elementary example, the 'slide' of the shadow on a vertical plane. The shadow is 'cut short' by the difference in level.*

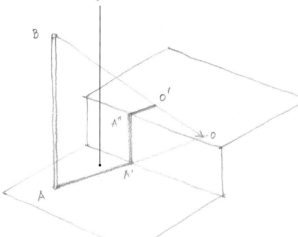

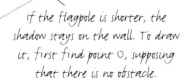

*If the flagpole is shorter, the shadow stays on the wall. To draw it, first find point O, supposing that there is no obstacle.*

## In the case of steps

What happens when the shadow of a horizontal line, like the top of this low wall, is projected on to a step, or when a shadow is projected onto an inclined plane?

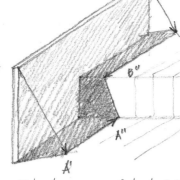

*Take the two parts of the shaded zone separately: A'A'' on the low part of the step and B''B' on the top part. Then join up these two parts.*

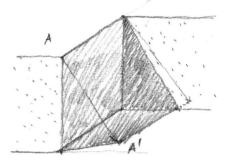

*Do the same thing for the return of the step.*

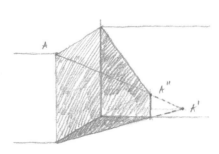

*And if the depth of the return is slight, the shadow can break on the vertical part.*

*You must first place the shadow on the ground plan, and then in stages deal with the displacements caused by relief or accident.*

45

# Working with tone values

The values of the shadows in a sketch, like colours, are never flat. They include subtle variations and modulations which change the perception of plans and extensions, and help to bring the drawing to life.

## Some principles to remember

The air tends to blur contrasts with distance. This rule can be applied even if the distances are very small. Reinforce the nearest shadows. This principle includes another, by contrast: horizontal shadows (on the ground) are darker than vertical ones which are often simply own shadows. For the latter we consider that they receive a little ambient reflected light which lightens them. In general own shadows are lighter than cast shadows.

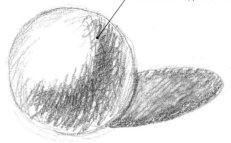

*The shadow is more or less contrasted according to the material, until it gives a metallic effect, as here.*

*surfaces don't have the same luminosity according to their position. We give a lighter value to the vertical surfaces, in order to bring out the horizontal ones.*

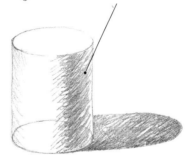

*With spheres, cylinders and all curved surfaces the passage from light to shade does not have a border: it is progressive and gives a characteristic gradation.*

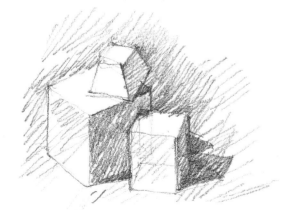

*The shadow becomes darker and darker as it approaches the object, then lightens when it becomes the object's own shadow.*

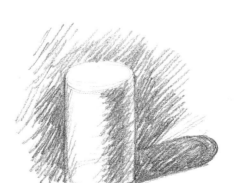

*straight surfaces have more contrast. The shadowed surfaces here are therefore darker. Reinforce the contrast at the edges of the shadow and soften it in the interior.*

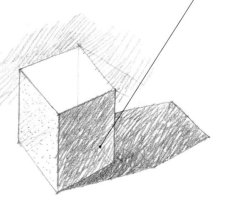

## The shadow reveals the object

According to whether the volume is wholly shadowed or not, the object changes, looses or takes on weight and form. The series of views below show one of the uses of cast shadows in representation: it reveals some aspects not discernable with the ground plan alone. We thus have a series of ten objects, apparently identical, seen from above and all looking like a square. However, the shadows are different, like the volumes.

For each of these figures, we have below the diagram of the view in elevation.

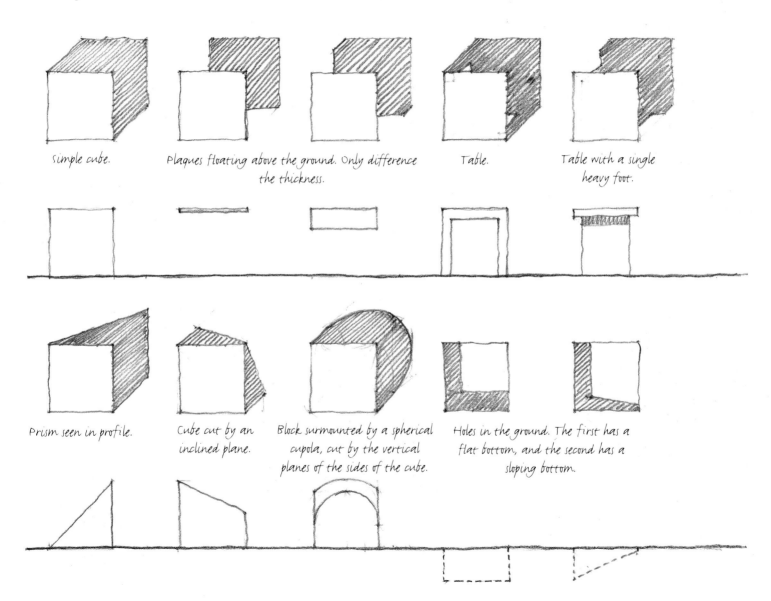

simple cube.

Plaques floating above the ground. Only difference the thickness.

Table.

Table with a single heavy foot.

Prism seen in profile.

Cube cut by an inclined plane.

Block surmounted by a spherical cupola, cut by the vertical planes of the sides of the cube.

Holes in the ground. The first has a flat bottom, and the second has a sloping bottom.

47

# Prisms and extrusions

Mastering the principles of isometric perspective, extrusion and highlighting, enables us to explore objects and geometric forms more easily.

## Mastering elementary forms

These are also called 'primitive' in computer-assisted drawing. The majority of manufactured objects that surround us are the result of a complex assembly of these elementary forms.

Some bodies are composed according to recurrent principles, from a profile that extends, such as a cube or a cylinder. First imagine an outline, draw it in isometric perspective and generate the corresponding volume by raising the vertical or horizontal lines as in the profile opposite.

## Cylinders and cones

The cylinder is simple in principle, but its drawing reveals some difficulties which are essentially in positioning and drawing the ellipses. First draw the entire ellipse of the contours, even the part that is hidden. Draw it lightly, placing it in the whole drawing.

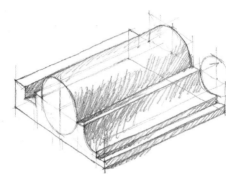

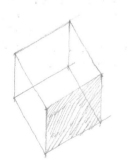

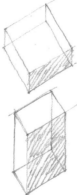

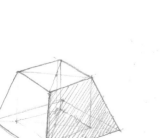

*Practise making linear drawings of bodies, starting with simple shapes, planes, and gradually building up your drawing.*

*Avoid drawing two arcs of a circle that intersect.*

*Draw a complete ellipse.*

*The ellipses must turn without cutting the tangents.*

## The base of the cylinder

It is the orientation of the base that is tricky. The simplest way is to start with a square whose median axes are symmetrical in relation to the horizontal and vertical lines.

*Here, the axes are not symmetrical, the ellipse is tilted and the cylinder seems distorted.*

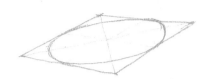

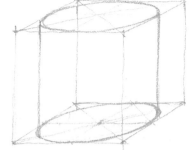

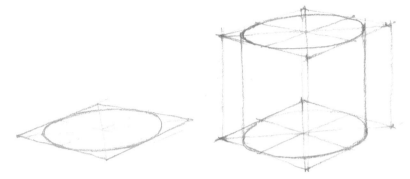

*Observe that if the ellipse is tilted, its axes are not the diagonals of the square in which the circle is drawn, nor are they the points of contact of the tangents which form the contour of the cylinder.*

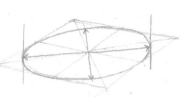

## The exterior shadow of the cylinder

After drawing the shadow of the top circle, trace the tangents of the base circle, direction parallel to the drawing of the ray of light. The plane between light and shade on the cylinder is vertical to the tangent point.

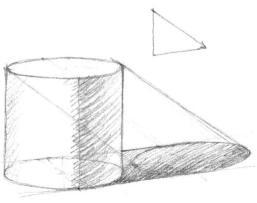

## The exterior shadow of the cone

With the cone, we draw the ray of light down from the summit of the cone. If the ray stays inside the cone, there is no shadow. From the shadow of the summit on the ground, we draw tangents to the base circle. The two tangent points linking up at the summit of the cone give the planes between light and shade, which are theoretical as the passage from light to shade is progressive.

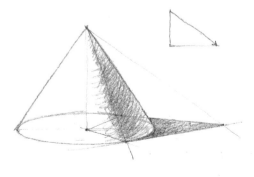

## The interior shadow of the cylinder

This is a little more complex. You have to remember that all the rays of light passing across the opening of the cylinder form another cylinder, virtual and flattened. It is this cylinder that casts the shadow on the ground, but it also give the interior shadow.

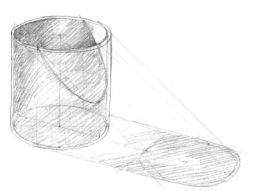

49

# Spheres and revolutions

The sphere appears as a circle. So in general it is not necessary to resort to a complex construction. On the other hand, for part of a sphere that forms part of an ensemble, it is often necessary to make a construction.

### The construction of the sphere

It is an exercise in synthesis, drawing ellipses and making a cube. It consists of identifying three perpendicular flat plans, in which we draw three circles. The sphere will be drawn enveloping the three circles by a fourth which forms the contour we can see. If the preparatory construction is not accurate, it will be immediately apparent, for the outside circle will look like a potato.

Proceed as follows, finishing with the volume. Here, I have deleted a quarter of the sphere to show the three circles of construction.

1   Draw a square on a flat plan, then a circle inside the square (seen as an ellipse).

2   Draw a second square on a vertical plan, passing by the diameter of the first circle, and draw a new ellipse.

3   Start again on a vertical plan, perpendicular to the preceding one, obtaining thus three circles.

4   Draw the circle that envelopes this construction and which is the outline of the sphere.

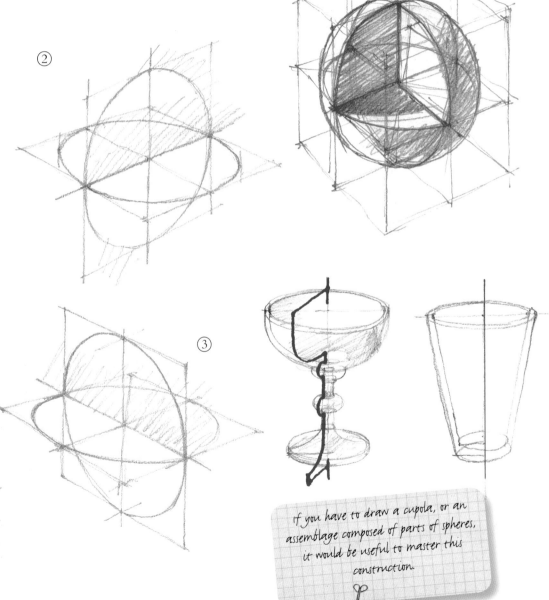

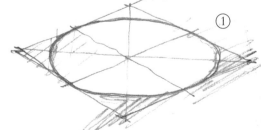

*If you have to draw a cupola, or an assemblage composed of parts of spheres, it would be useful to master this construction.*

## The torus

To develop your knowledge of ellipses, nothing is better than drawing a torus, partial or complete.

The torus is a volume created by placing a circle around the centre of another, larger, circle. In turning, the small circle stays perpendicular to the 'road' formed by the big circle. The rotation of the small circle creates an infinite number of circles seen as ellipses which enable you to verify the construction.

1   Start by drawing a horizontal square, then draw the two circles of construction (A and B), as well as one corresponding to the diameter C.

2   Then draw the three circles corresponding to the ends and the middle of the torus, D, E and F.

3 and 4   Draw the circles in between. You have to multiply the corresponding vertical and horizontal straight lines in order to best prepare for drawing the curved shapes with precision.

5   Finish by drawing all the circles of the construction.

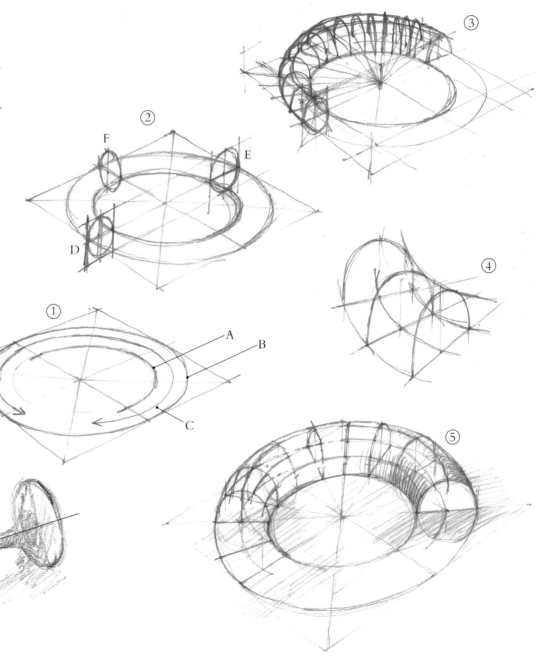

# The block diagram and the landscape seen in relief

The block diagram is used in geography to show relief, and sometimes the underlying geological strata. It is an excellent way of studying a site, a landscape or the terrain, when it is a little irregular.

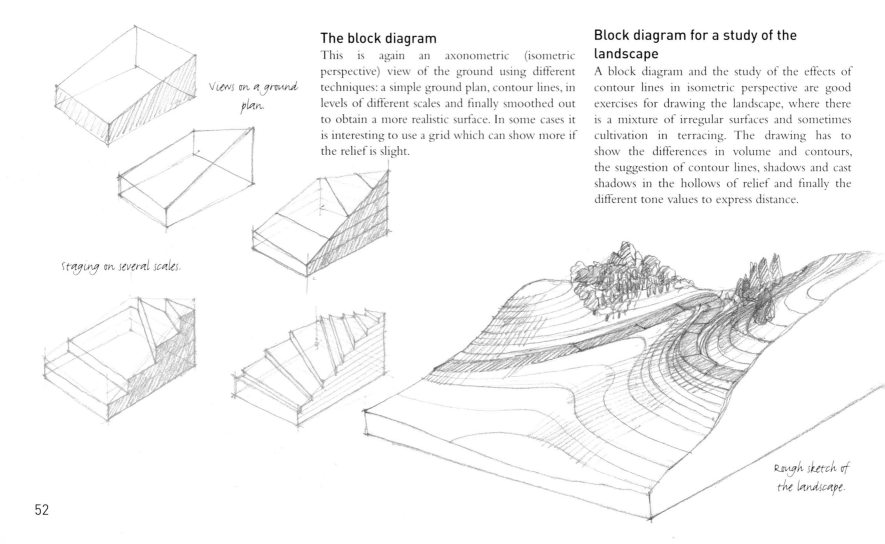

*Views on a ground plan.*

*staging on several scales.*

### The block diagram

This is again an axonometric (isometric perspective) view of the ground using different techniques: a simple ground plan, contour lines, in levels of different scales and finally smoothed out to obtain a more realistic surface. In some cases it is interesting to use a grid which can show more if the relief is slight.

### Block diagram for a study of the landscape

A block diagram and the study of the effects of contour lines in isometric perspective are good exercises for drawing the landscape, where there is a mixture of irregular surfaces and sometimes cultivation in terracing. The drawing has to show the differences in volume and contours, the suggestion of contour lines, shadows and cast shadows in the hollows of relief and finally the different tone values to express distance.

*Rough sketch of the landscape.*

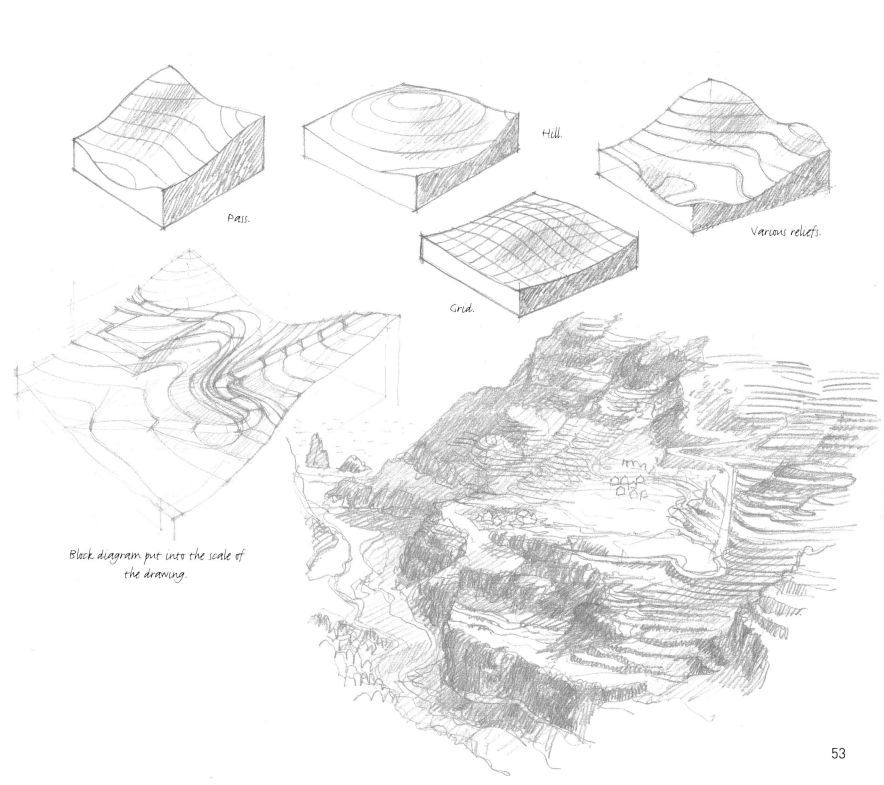

Pass.

Hill.

Various reliefs.

Grid.

Block diagram put into the scale of
the drawing.

# Creating a body in three dimensions

Having familiarised yourself with constructing various kinds of volume, you now have some exercises in assembling volume by addition. Starting with two volumes that match up, how do you get a single one, with all the constituent parts of each.

## Simple addition of two volumes

You have to find a common denominator between the two volumes, to put them in the same frame of reference. The simplest is to take the ground as the frame of reference, considering that the two volumes are placed on it. Thus we can always find the position of one point, and then construct lines in common, such as the intersections of surfaces and edges.

1  First draw the two independent volumes, transparent, without defining intersections.

2  Locate where the two bases intersect with the ground. From these points, build up the side walls as the arrows show.

3  Work on showing the volume obtained.

*Vary the scenario by turning the volumes and varying the point of view, including the parts hidden.*

①

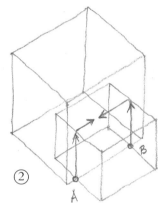
②

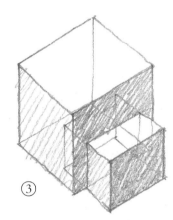
③

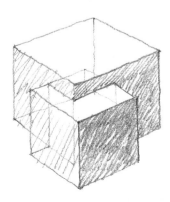

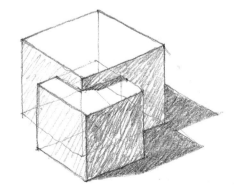

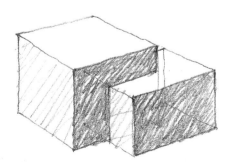

# Three kinds of figure

Note that the same transparent drawing at the beginning, with no intersections and no reference to the ground, can give different impressions.

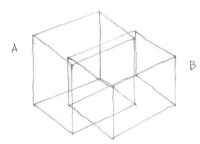

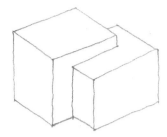

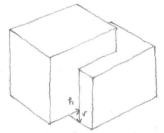

Two transparent blocks A and B, placed on the ground.

The two blocks A and B, placed on the ground.

Block B is lifted up on a vertical line V to the distance h.

Here, it is block A that has been lifted to height V.

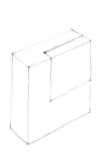

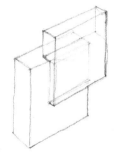

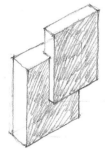

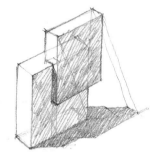

Association of two volumes seen from above, with shadows.

Starting with figures arranged at random, try to define the volumes and construct the intersections.

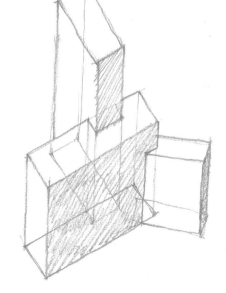

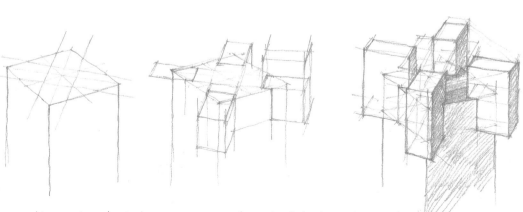

Carpentry joints and mechanical constructions are the result of this kind of manipulation.

55

# Making a volume by subtraction

This shows a method rather than an operation of subtraction.
From one figure how do you obtain several volumes?

### Subtracting volumes

1    Draw one block, then on its surface draw the traces of two secondary blocks.

2    Remove these two blocks from the main block.

3    On this block draw the outline of a third volume.

4    Subtract the volume corresponding to this new drawing.

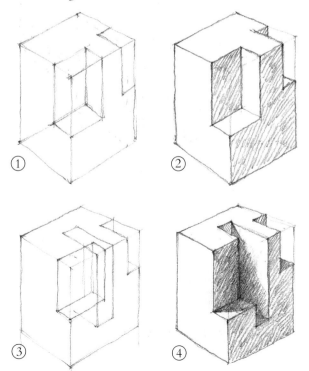

① ② ③ ④

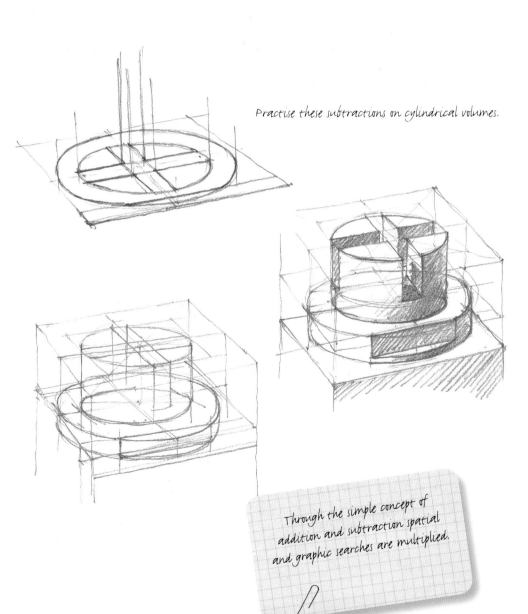

*Practise these subtractions on cylindrical volumes.*

*Through the simple concept of addition and subtraction spatial and graphic searches are multiplied.*

## Plaques and bars

Drawing solid objects reveals one difficulty, due to the difference in scale between the general body of the object and the details. Bars, pieces of carpentry, or simply streets with their border of pavements, have this particularity which we call 'thickness of line', or depth.

To recreate this thickness it is necessary to master the detail of the drawing. You have to study the intersections between the different linear volumes, and marry the expression of these details with the expression of the proportions of the whole, and with an equal scale between the small and large dimensions

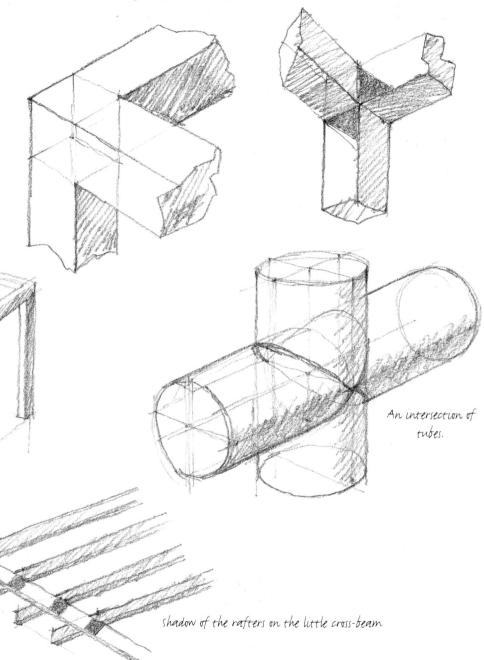

study the joins of the square bars with the shadows.

An intersection of tubes.

Drawing of a table which is going to have a glass top. It is necessary to study in close-up the horizontal and vertical elements before drawing them in small scale.

shadow of the rafters on the little cross-beam

# SEEING IN PERSPECTIVE

Drawing in perspective is first of all drawing what you see in front of you.
Understanding the phenomenon of perspective vision is essential. In this
chapter therefore we examine some of the essential facts about perspective,
in which the question of drawing is only in the background.
At the end of the chapter we come back to the problems of drawing.

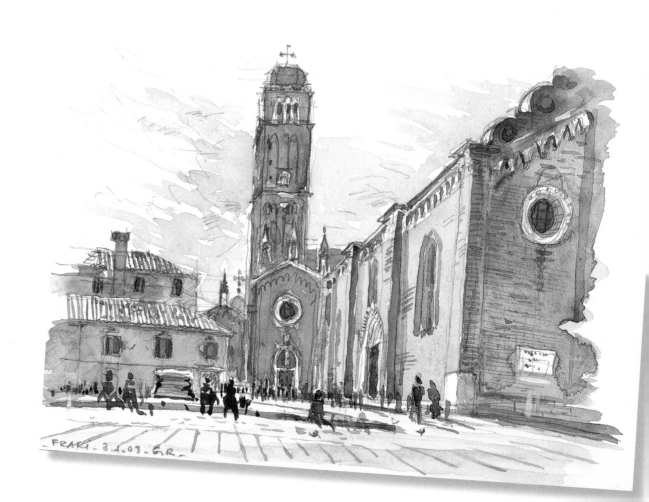

# The eye view

The eye gives us a specific point of view of the world from one point. This has a fundamental consequence: the view is angular (in fact it is conical, but diagrammatically we can call it angular), an angle with the eye at the summit. This angle at which we see an object narrows if the object moves further away. For us, this translates into an apparent diminishing in size of the object. The effect is the basis of perspective.

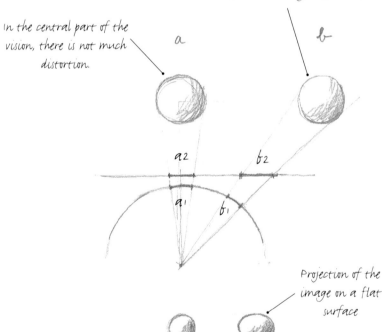

PROJECTION OF THE IMAGE OF TWO SPHERES ON A CURVED SURFACE AND A FLAT SURFACE

There are distortions at the edges. $a_2$ is near $a_1$, but $b_2$ is very different from $b_1$.

In the central part of the vision, there is not much distortion.

$a$       $b$

$a_2$       $b_2$

$a_1$       $b_1$

Projection of the image on a flat surface

What the eye sees.

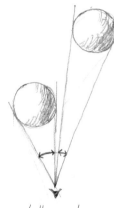

The two balls are the same size, but at different distances

What the eye sees.

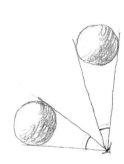

The two balls are still at different distances, but the connection between the distances has diminished.

What the eye sees.

## The importance of the point of view

Our vision depends on our position; our point of view. If we move, our view of the same balls is changed. Taking into account our position in a space is an important element of drawing in perspective. Another factor, more difficult to define, plays an important part in perspective drawing: our vision is a projection onto a curved surface, the back of the eye. It is already an image, and the drawing that we make on a sheet of paper is only an attempt at reproducing that image. There is a geometric difference between these two surfaces, because that of the eye is spherical, while that of the paper is flat.

## Changing the angle of sight

A good part of the difficulties encountered when learning to draw in perspective, especially nature drawing, comes from these distortions. One compensates for them by simplifications that can be disconcerting to the beginner. Here is a summary to warn against doubts that would be quite legitimate!

You have probably had a similar experience with a camera: if the camera is not strictly lined up with the horizontal, the vertical lines will not be parallel in the photo (there are all the same special lenses for photographing tall pieces of furniture, keeping the vertical lines parallel, without cutting off the top of the furniture). These problems are usually present at the sides of the vision. If we content ourselves with drawing the central part, the drawing is much easier because it corresponds more faithfully to the vision of the eye.

However, naturally we feel the need to reproduce the larger view, and there the problems start. A little technical knowledge will nevertheless allow us to overcome them.

*Remember that at the back of the eye the image is reversed. We have no awareness of it, because we have acquired a logical knowledge of reality.*

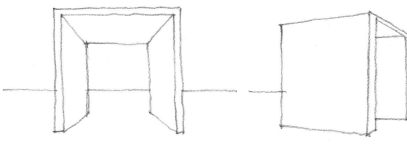

Here is a hollowed-out cube
placed in front of you.

The same cube from the side,
drawn moving to the left.

The same cube face on, as it is projected on the
back of the eye. However, you don't feel you are
seeing that because you make an unconscious
adjustment between the reality of the object
(straight lines) and your vision.

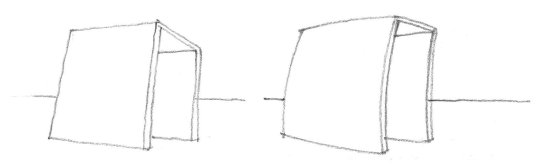

These drawings take account of the vertical vanishing lines, which
generally we don't do, unless the view is very oriented towards the
top or the bottom.

61

# Perspective in nature

Thinking about perspective, we have in our heads geometric constructions, such as in the world of straight lines and parallels, as in architecture. However, in the countryside there are also effects of perspective – apparent reductions in size – produced by distance.

## Our perception of the landscape

The familiar, repetitive character of the elements (trees, for instance) enables us to compare them and experience their distance. The sketches opposite demonstrate this phenomenon: it would be different with meteorites, for instance, objects that we are not in the habit of sketching.

Besides, the countryside is rarely completely natural. You can find roads, canals etc, things man-made and possessing a certain regularity.

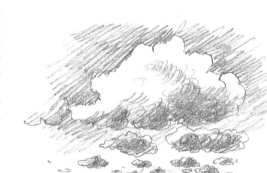

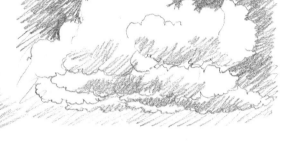

*Drawings of clouds, waves on the sea or a great grassy plain enable us to perceive the effect of distance.*

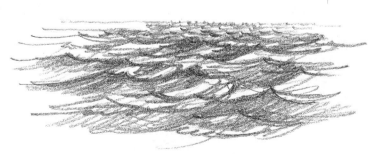

*Often a very straight line, like a railway line or an avenue, clearly illustrates the basis of linear perspective.*

## Atmospheric perspective

There is another family of perspectives, called atmospheric perspective. It is the effect of the air, which becomes slightly opaque with distance, changing colours and tone values. The latter becomes duller, while the colours tend towards blue. Accentuating tone values in drawing volume, even in axonometry, as we have seen on p.46, is an atmospheric-type effect, almost a caricature, as the distances are not great, yet nevertheless expressive.

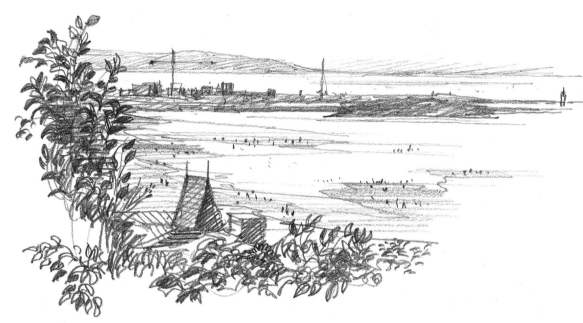

In this view of the Bay of Trouville at low tide, the distances are shown more by the differences in tone values in the far distance than by the size of the various elements.

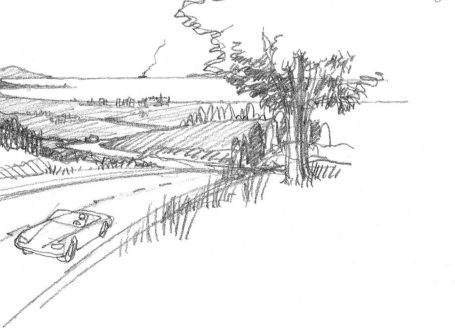

showing the ground is always very important in perspective, for it is the common denominator. It links all the elements and enables us to place them in relation to each other.

## Analysis of perspective

In the drawing below, the curve of the path clearly shows the beginning of geometric perspective. This is a little complex, generating several vanishing points. These drawings show us that if natural perspective is at bottom quite simple, it can rapidly bring complex notions into play, for natural objects gather together all the character of geometric objects, including a little disorder.

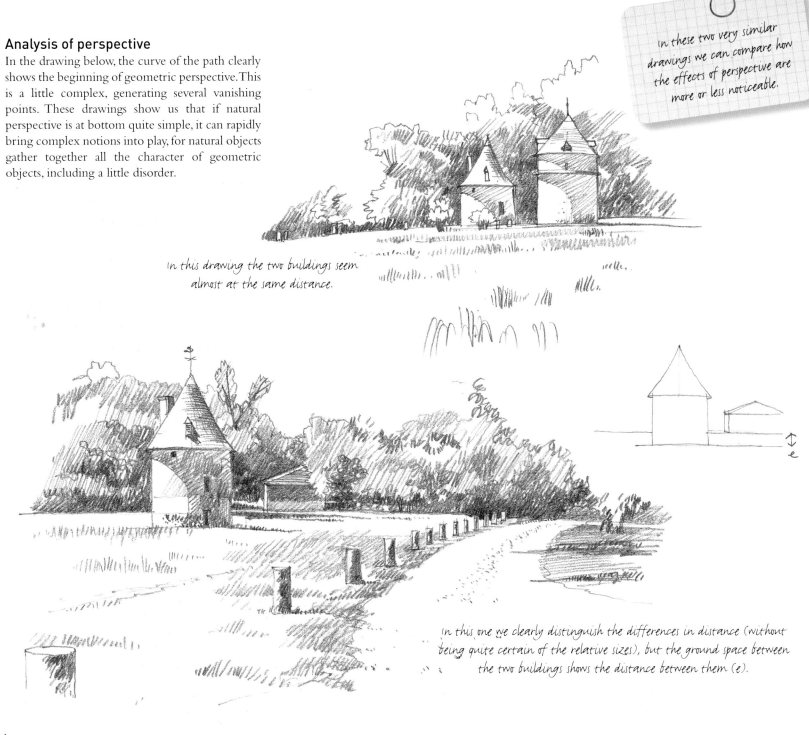

In these two very similar drawings we can compare how the effects of perspective are more or less noticeable.

In this drawing the two buildings seem almost at the same distance.

In this one we clearly distinguish the differences in distance (without being quite certain of the relative sizes), but the ground space between the two buildings shows the distance between them (e).

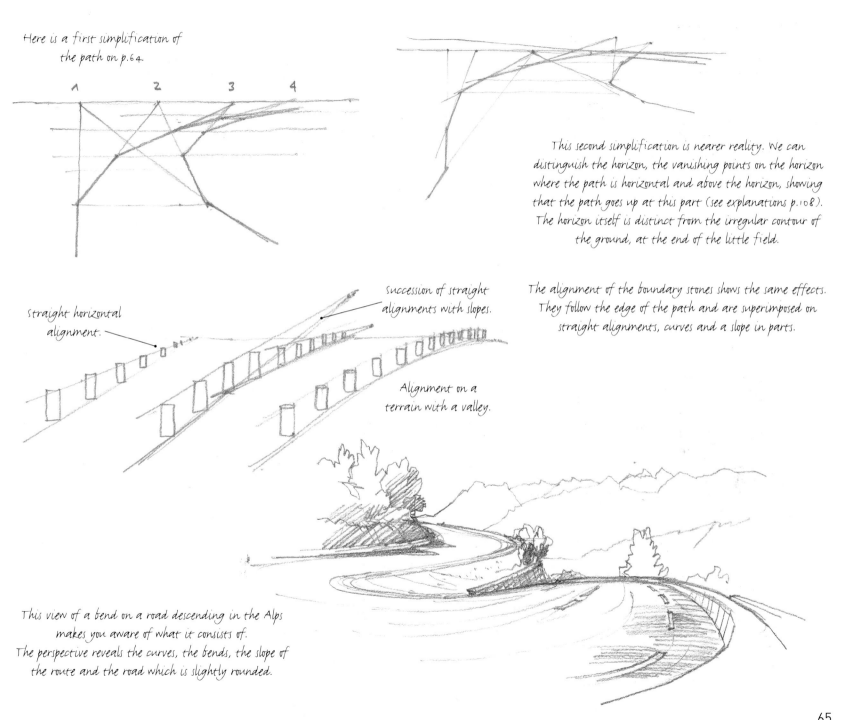

Here is a first simplification of
the path on p.64.

1  2  3  4

This second simplification is nearer reality. We can
distinguish the horizon, the vanishing points on the horizon
where the path is horizontal and above the horizon, showing
that the path goes up at this part (see explanations p.108).
The horizon itself is distinct from the irregular contour of
the ground, at the end of the little field.

straight horizontal
alignment.

Succession of straight
alignments with slopes.

The alignment of the boundary stones shows the same effects.
They follow the edge of the path and are superimposed on
straight alignments, curves and a slope in parts.

Alignment on a
terrain with a valley.

This view of a bend on a road descending in the Alps
makes you aware of what it consists of.
The perspective reveals the curves, the bends, the slope of
the route and the road which is slightly rounded.

# Analysing the landscape

When you start a drawing of a landscape, you have to deconstruct the view into its components, analysing and grading these various parts. A drawing is a good medium for observation.

*Note that the courses of stones in the wall on the right, in spite of their apparent disorder, run towards the same point on the horizon.*

## Simplify

The first thing to do is to put the horizon into your drawing, deciding what position you are going to give it. Here we have a view from a terrace above a little village. The horizon is very high up in the drawing, to make room for what is below. The houses scattered about follow the laws of perspective, but are difficult to show in detail because there are too many of them.

Here, we can only use a 'photographic' composition, that's to say step by step, as if copying a flat drawing. However, as soon as you locate two parallel lines, such as the edges of a roof, you have to verify that these lines, if extended, meet up on the horizon.

*A little sketch beforehand allows us to define the encircling lines of relief and the large elements: the succession of woods in horizontal lines on the distant plain, the gash in the cliff that shows the view.*

## Locate the geometric features

In a landscape we can often also recognise characteristic 'micro landscapes', like this bend in the river. We can see there the trees, their trunks and the river on a slope, an ensemble that makes a concave shape in which the opposite bank appears in the distance, with just a little clear space indicating the width of the river. These details are very important, for they have a symbolic function: we have already seen them and we read them in a landscape like the words in a sentence. They play an essential role in identifying a place and thus in the quality of description in the drawing.

The two aspects, geometric and symbolic, come together in the graphic arts as in a patch of grass and this graphic art is inscribed in an effect of reduction and distance

Finally, it is always better to show slight differences in tones to express different distances: here, the main drawing has tones and we can be content with evoking them by thicknesses of line, which is also purely symbolic as the contour line, which doesn't exist in reality, has no reason to change its thickness.

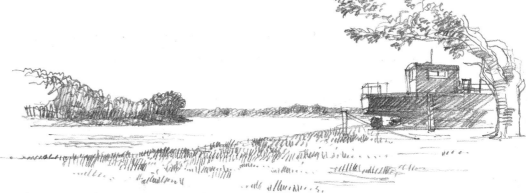

The Garonne. The natural irregular elements appear as a question of curves.

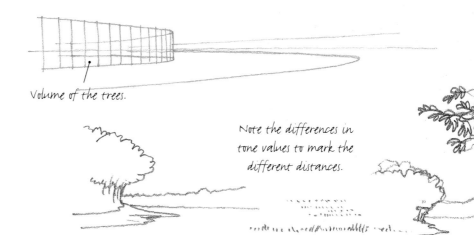

Volume of the trees.

Note the differences in tone values to mark the different distances.

A river is a good example of a natural element that comes up in perspective. Its banks are parallel and horizontal, but they are rarely rectilinear. Study how natural irregular elements appear in geometric forms and in regular perspectives.

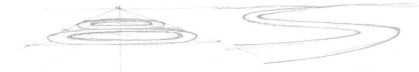

# The vanishing point

When practising drawing in perspective, it is very important to know how to locate a vanishing point before putting it down in a drawing. This locating is not linked to the drawing itself, and I strongly advise you to learn how to do it from now on.

## What is a vanishing point?

If we look at straight parallel lines they seem to join up at a point that seems itself to be in infinity: this is the vanishing point. The lines that lead to this point are called 'vanishing' or vanishing lines. This phenomenon is only produced practically in an architectural or urban environment, where such lines exist like the cornices of houses and the numerous lines of windows, parallel to some general directions, like those of the street, for example. In nature, they are hardly ever encountered. There, we only perceive perspective through the effect of reduction in size.

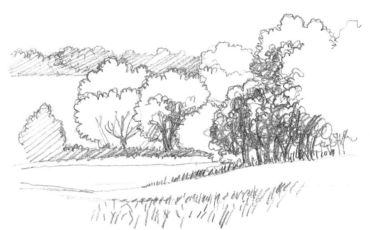

The idea of a vanishing point is practically absent from this natural space.

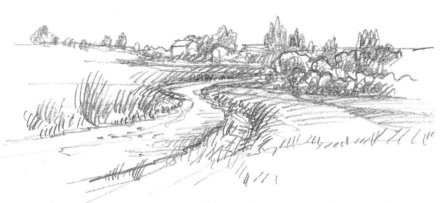

We begin to feel the effect of the vanishing line on this road which is already an architectural beginning (with its parallel lines).

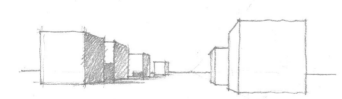

The perception of a vanishing point is reinforced when objects follow straight lines.

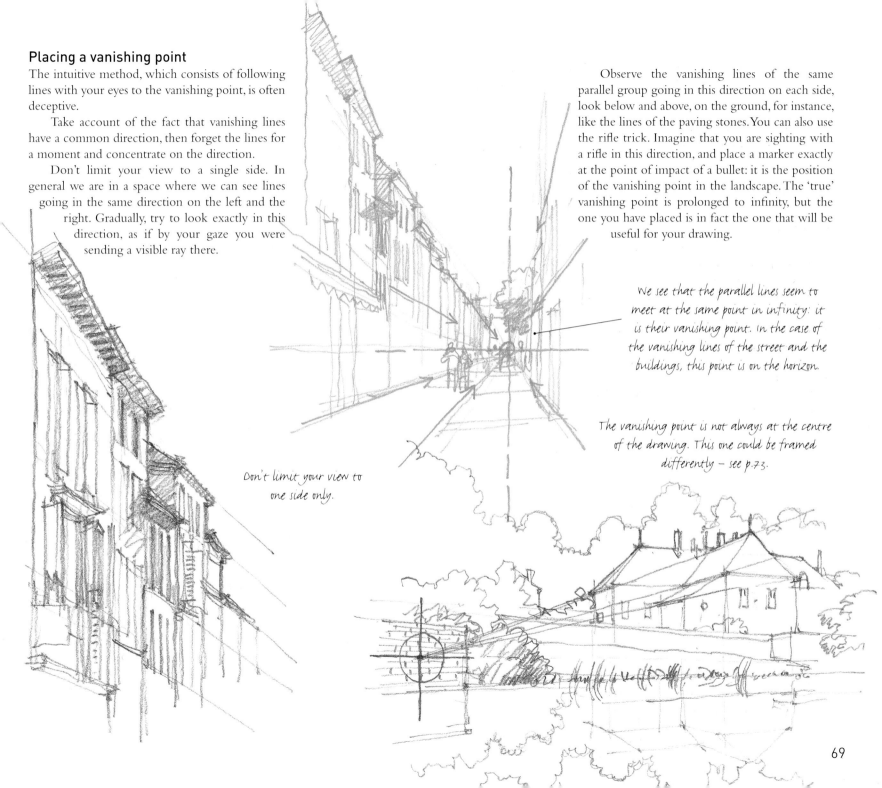

## Placing a vanishing point

The intuitive method, which consists of following lines with your eyes to the vanishing point, is often deceptive.

Take account of the fact that vanishing lines have a common direction, then forget the lines for a moment and concentrate on the direction.

Don't limit your view to a single side. In general we are in a space where we can see lines going in the same direction on the left and the right. Gradually, try to look exactly in this direction, as if by your gaze you were sending a visible ray there.

Observe the vanishing lines of the same parallel group going in this direction on each side, look below and above, on the ground, for instance, like the lines of the paving stones. You can also use the rifle trick. Imagine that you are sighting with a rifle in this direction, and place a marker exactly at the point of impact of a bullet: it is the position of the vanishing point in the landscape. The 'true' vanishing point is prolonged to infinity, but the one you have placed is in fact the one that will be useful for your drawing.

We see that the parallel lines seem to meet at the same point in infinity: it is their vanishing point. In the case of the vanishing lines of the street and the buildings, this point is on the horizon.

The vanishing point is not always at the centre of the drawing. This one could be framed differently – see p.73.

Don't limit your view to one side only.

## The vanishing point follows you

If you have taken in all the preceding information, you can draw this conclusion: if you move, always looking in the same direction (and keeping the rifle parallel to the direction) the vanishing point moves in the landscape (and you won't touch the same target with the rifle).

When we move, the vanishing point of the lines in one direction seem to move at the same time as us. We can experience it in a room, observing the vanishing lines of a tiled floor. The real vanishing point doesn't move, for being at infinity it isn't affected by this move. However, those that you can place in the landscape move effectively to the bottom of the landscape. In particular, it changes height when you change height.

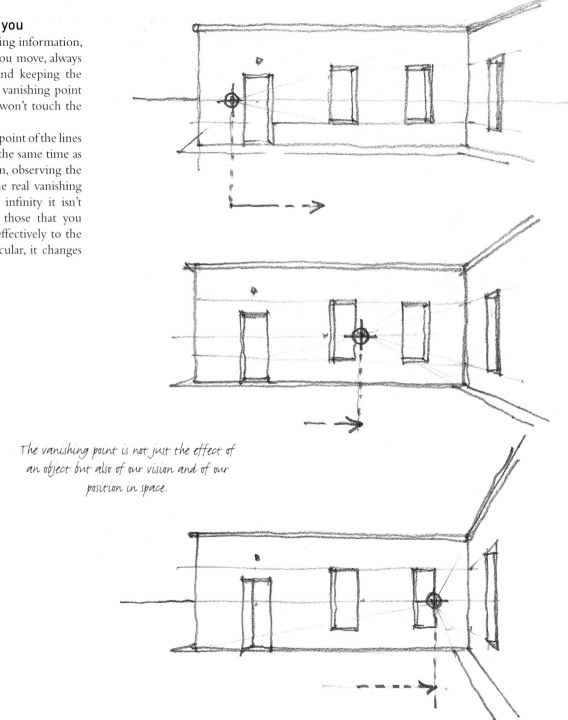

*The vanishing point is not just the effect of an object but also of our vision and of our position in space.*

70

### The vanishing point of horizontal lines is at eye level

In the two drawings below you can see a person. Imagine that he is exactly opposite you. You will see that the vanishing point follows your move in height, and the characteristic line is that it is precisely at the height of your eyes.

In fact here, the lines whose vanishing point we are following are the horizontal lines of construction. The direction is thus horizontal, and the point seen in this direction is at the same height as the eyes. It is an important point to remember for perspective in architecture or in a town, for most of the lines for which we are seeking the vanishing point will be horizontal.

### Subjective nature of the vanishing point

From that we can deduce that the vanishing point is partly subjective: the vanishing lines are independent of our regard and vanish towards a unique, static point, but the view we have of them depends on our own position in the space.

*Note the movement of the vanishing lines. When we go up higher, all the landscape of the courtyard is changed. The roof is more apparent, as much as the ground.*

### The 'true' vanishing point and the one that we see

There is a troubling question that we must clear up. The vanishing point is an imaginary point situated in infinity. This is what I call the 'true' vanishing point. But when we observe the vanishing lines in a space, we don't see as far as this point in infinity. The landscape is blocked by an obstacle, like the building opposite us in the drawing below. The line of sight, parallel to the direction of the vanishing lines, then bumps against a point which I call the 'seen' vanishing point. In the practice of drawing, it is that that you must find amongst the elements.

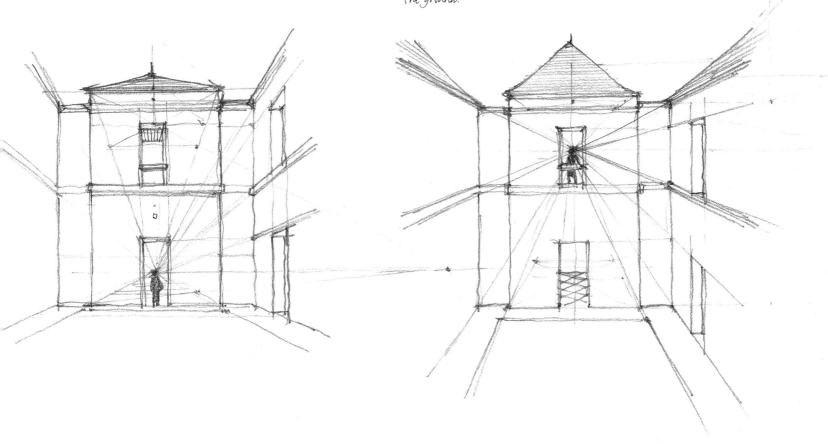

# The horizon

In perspective the horizon is the line that joins all the vanishing points from the horizontal direction. Among all the parallel lines possible, some are horizontal and others can be at an angle. The majority are in fact horizontal or vertical. Among the horizontal lines there is again an infinite number of directions around you. Each direction generates a vanishing point.

*Observe these vanishing points: they are aligned along a line which is the horizon. It doesn't appear of course, and often it is hidden in the landscape. It is advisable to draw the horizon in all drawings, either in nature or in your imaginary one, for it is the main point of reference for constructing a perspective.*

### Concerning the horizon

Is the horizon the line we can see above the sea the horizon of the perspective? The answer is no! The natural horizon is the apparent contour of the large sphere (the Earth) on which you are standing. It is a curved line, very extended, and in fact situated lower than your eyes. While the perspective horizon is at eye level, it is the outcome of the horizontal lines. At the height of a pedestrian on the ground, the difference is not perceptible, but views from a satellite, taken at hundreds of miles of altitude, already show well the curvature of the Earth.

*The cornices of houses seem to be leaning forward, but in fact they are completely horizontal, like the floors.*

## The height of the horizon

As the vanishing point of horizontal lines is at eye level (see p.71) the horizon is too, necessarily. The horizon is thus also a subjective idea. If you want to put in the horizon, find some elements in the landscape at your eye level, for example some passers-by at the other side of the street: their heads are more or less at the same height as yours. You only have to join them up to define the horizon. In a street, the horizon is about the middle of the shop facades. Beginners often place it towards the second floor.

## The horizon in the drawing

In the drawing it is the artist who places the horizon, low if he wants rather to show what is above the horizon (and himself), like the sky and the clouds; or on the contrary, high up in the drawing, if he wants to show what is lower than the horizon on the first plan.

The artist has chosen as his principal subject the top part of the landscape: the sky, the clouds.

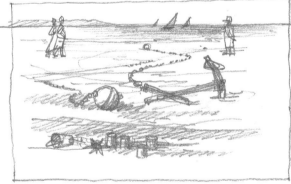

The artist has chosen as his principal subject the bottom part of the landscape: the beach, the walkers.

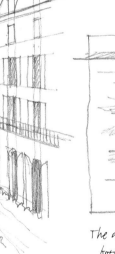

Theoretically, if we extend the vanishing lines from the house, we would obtain a vanishing point just above the horizon of the sea. In fact the difference is not perceptible.

In the sketch of a house beside the sea, the horizon is just below the level of the balcony, at the level of the windows on the first floor. This tells us implicitly what the height of the artist is.

The artist has gone to the level of the second floor. The horizon (his horizon) has gone up at the same time, and more of the beach is shown.

IN THESE TWO CASES THE VANISHING POINTS ARE CERTAINLY ALWAYS ON THE HORIZON.

73

# The concept of the picture plane

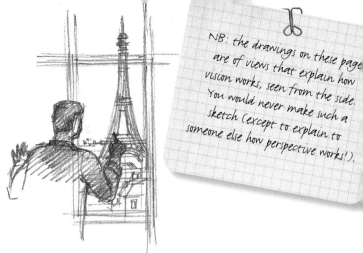

NB: the drawings on these pages are of views that explain how vision works, seen from the side. You would never make such a sketch (except to explain to someone else how perspective works!).

We are now going to tackle drawn perspective. Everyone has tried to draw the landscape seen through the window on the window pane. The glass is at that moment exactly the materialisation of what we call the 'picture plane'. When we draw the landscape, we only reproduce what is projected onto this transparent plane.

## The picture plane

When we are drawing what is in front of us on a sheet of paper, we are drawing as if on this picture plane. The picture plane is the place where what was in three dimensions comes down to two dimensions. If we are constructing from plans and elevations, this geometric concept is indispensable. In any case it is a notion that it is desirable to have well absorbed, to acquire some facility in all representations of perspective.

## The ground as a point of reference

If the observer, the picture plane and the object are placed on the ground, we can construct a projection by means of visual rays and place the points that give the image of the post. This principle is at the bottom of all perspective that starts with a ground plan.

What the observer sees.

This diagram illustrates the principle of the picture plane. The visual rays of the observer are intercepted by the picture plane. It would be enough to join up the points of intersection of the rays on this plane to obtain a drawing of the object, or the landscape. This drawing is impossible without a reference point between the observer, the object and the picture plane, for nothing allows us to find the intersections between the visual rays and the latter.

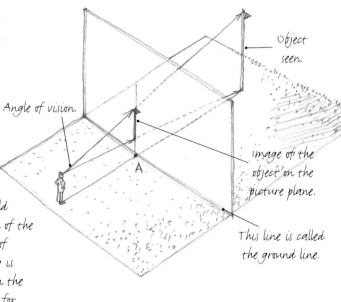

Object seen.

Angle of vision.

A

Image of the object on the picture plane.

This line is called the ground line.

## The scale of the picture plane

This drawing shows how to make use of the distance from the picture plane. When this is moved parallel to itself, the object on the picture plane changes size, but is not distorted.

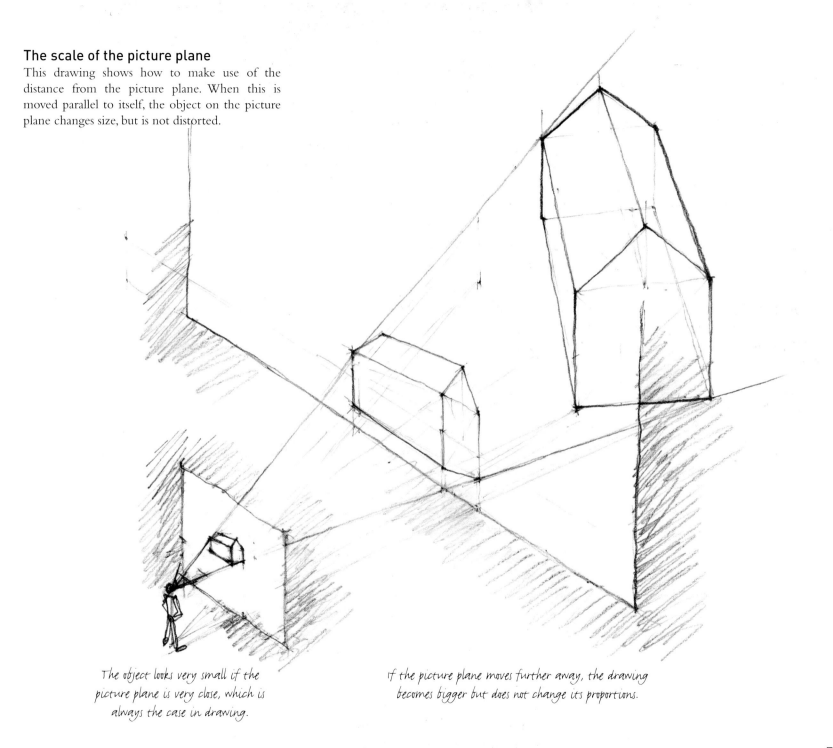

The object looks very small if the picture plane is very close, which is always the case in drawing.

If the picture plane moves further away, the drawing becomes bigger but does not change its proportions.

## The vanishing point on the picture plane

On the diagram below we show the perspective of two flag-poles, the same height, according to the principles explained earlier. If we reproduce the principle of locating the vanishing point shown on p. 69, we draw a line from the eye, parallel to the direction AB, which aligns the two poles. This line moves towards infinity to the right of the drawing, like AB, and CD which joins the feet of the poles. But it also meets the picture plane at a point PF, which is going to constitute the vanishing point of this direction on the picture plane. You can verify it by drawing the vanishing lines A'B' (PF) and C'D' (PF).

## The four vanishing points

Take care, the vanishing point can mean four things: the one that is at infinity, the one that is in the landscape (here on the wall), the one on the picture plane, and finally the one on the drawing. For the observer/draughtsman the first three are views merged at one point in the field of vision. When we talk about the vanishing point, we don't generally stipulate what is consists of, so it is sometimes useful to be aware of this plurality of meanings.

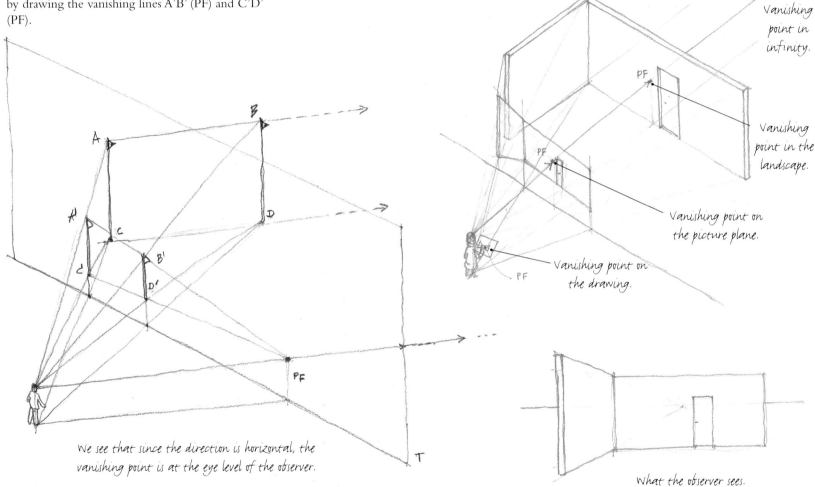

*This diagram shows the difference between the 'true vanishing point', situated at infinity (and absent from this drawing) and the vanishing point in the drawing.*

PF

Vanishing point in infinity.

Vanishing point in the landscape.

Vanishing point on the picture plane.

Vanishing point on the drawing.

PF

*We see that since the direction is horizontal, the vanishing point is at the eye level of the observer.*

T

What the observer sees.

## The horizon on the picture plane

The horizon is deduced in an analogue fashion. We see here two walls at right angles, with two directions, D1 and D2, generating two vanishing points, PF1 and PF2. If we join up these two vanishing points we obtain the horizon, at eye level to the observer.

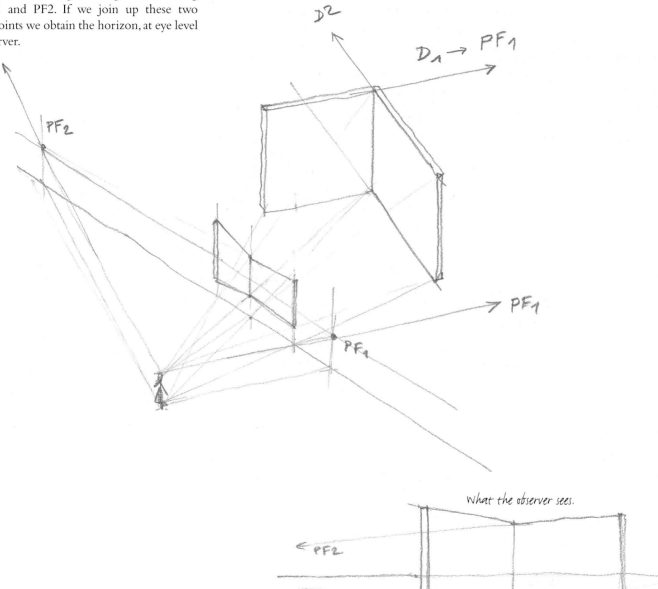

D2

$D_1 \rightarrow PF_1$

PF2

PF1

PF1

What the observer sees.

PF2

PF1

# Putting into practice in a sketch

The moment has come to synthesise the various ideas put forward in the previous pages: construction by division, and locating and placing some vanishing points and vanishing lines on the drawing.

## Choosing and framing the subject

This seems to be self-evident, but it always has to be done before drawing: define the subject and its limits as well as the elements that have to be put into the drawing to make it intelligible.

A framed drawing occupies a space, usually rectangular, bordered by vertical and horizontal lines. Mentally draw these lines on the landscape, in order to find which of its elements are going to be cut off by this border. Then work by successive divisions of this space.

Start by dividing the whole thing into two or three parts, vertically and horizontally, making use of noticable lines and divisions in the view. At the beginning the proportions of these divisions are a bit difficult to understand, for the objects are not all on the same level. The pencil is essential as a measuring tool (see p.10).

*Detail of the divisions, showing the study of the proportions. The numbers indicate the order of placement of the lines according to their importance in the view.*

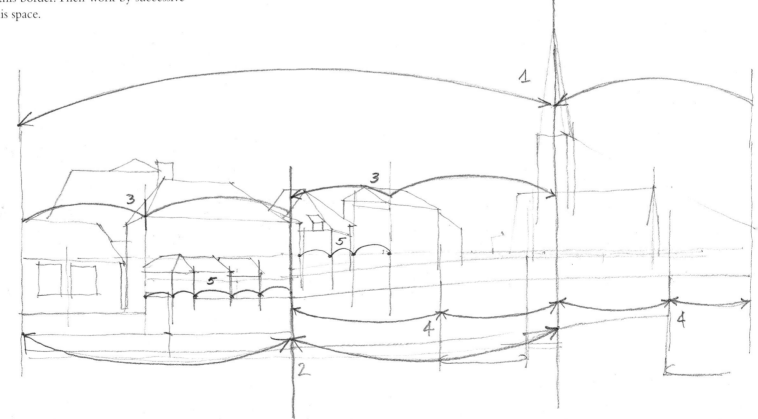

After the horizon, we put in the main vertical divisions.

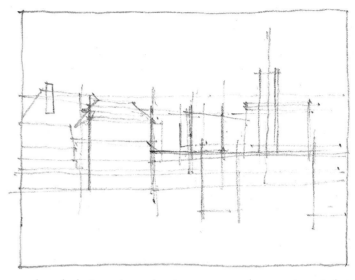

Then the horizontal ones, keeping an eye on the proportions of the rectangles this forms.

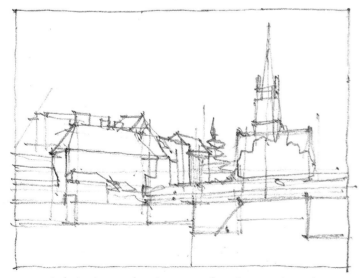

Little by little some bias lines (vanishing lines resulting from finding some vanishing points) give the effect of perspective.

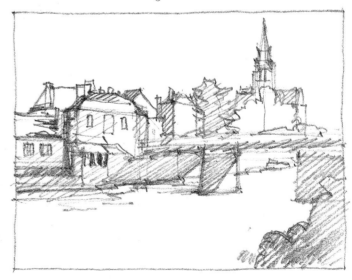

The outlines and the tonal values finish by giving the volumes.

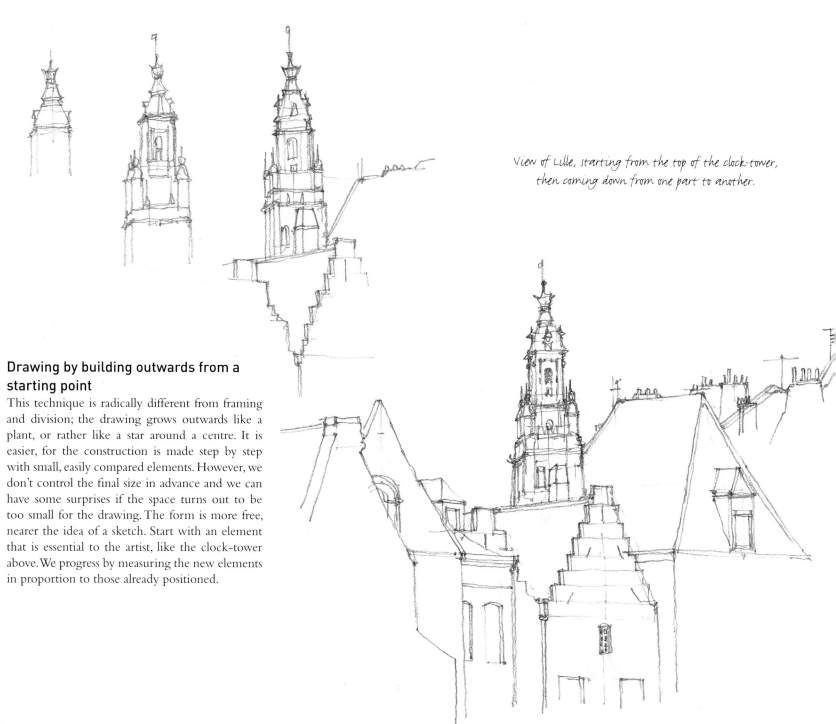

View of Lille, starting from the top of the clock-tower, then coming down from one part to another.

## Drawing by building outwards from a starting point

This technique is radically different from framing and division; the drawing grows outwards like a plant, or rather like a star around a centre. It is easier, for the construction is made step by step with small, easily compared elements. However, we don't control the final size in advance and we can have some surprises if the space turns out to be too small for the drawing. The form is more free, nearer the idea of a sketch. Start with an element that is essential to the artist, like the clock-tower above. We progress by measuring the new elements in proportion to those already positioned.

80

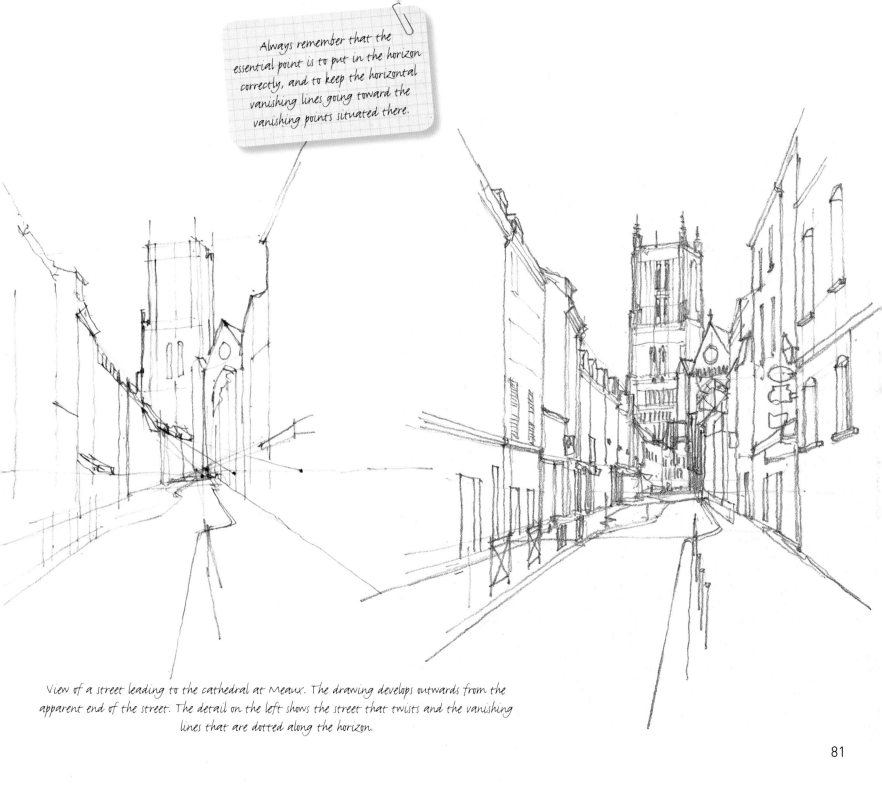

Always remember that the essential point is to put in the horizon correctly, and to keep the horizontal vanishing lines going toward the vanishing points situated there.

View of a street leading to the cathedral at Meaux. The drawing develops outwards from the apparent end of the street. The detail on the left shows the street that twists and the vanishing lines that are dotted along the horizon.

# THE FLAT-ON VIEW

This is the favoured view in architectural drawing. The main part is shown in elevation, that's to say facing us. A photograph makes the axis of the subject horizontal, and perpendicular to a part of the subject (the end of a square, for example) giving a frontal view.

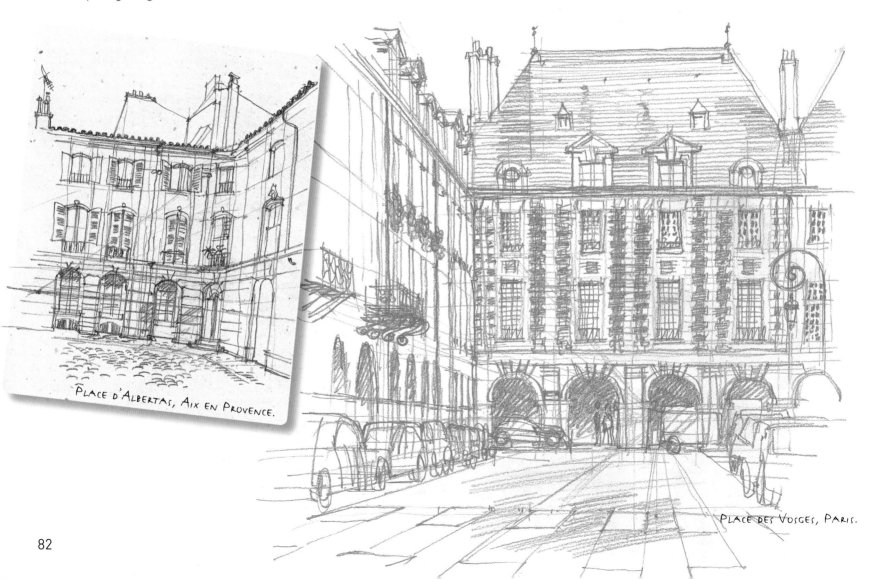

PLACE D'ALBERTAS, AIX EN PROVENCE.

PLACE DES VOSGES, PARIS.

POMPIDOU CENTRE, PARIS.

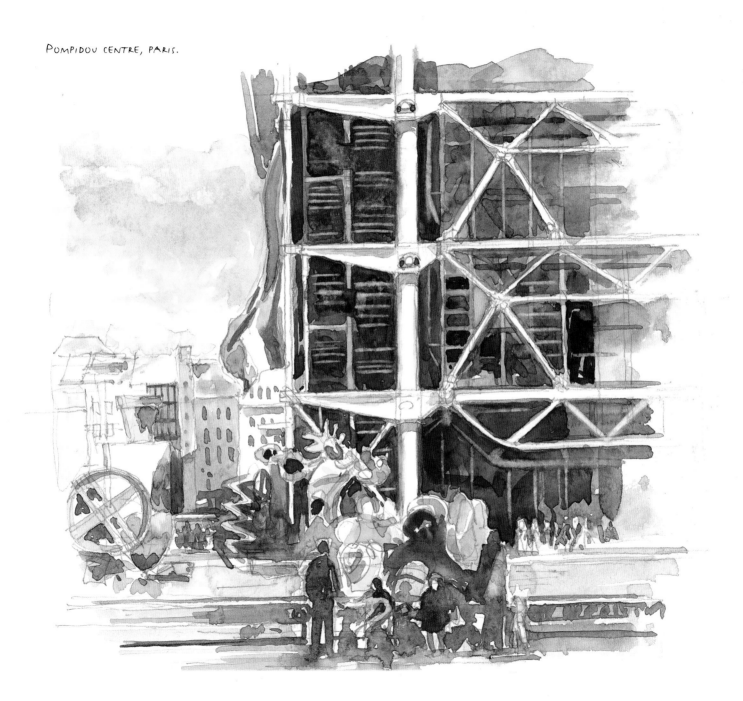

# The flat-on view

In flat-on views the lines stay parallel to the picture plane since they are not distorted by perspective, and the proportions are kept.

## Distinctive characteristics of the flat-on view

We can choose a scale and start a front-on view by drawing the part in elevation, from which we can draw the sides which are seen in perspective. It is thus a particular case which is useful to explore. Most often there is a part that we treat as the background, so that is doesn't conceal the foreground.

Otherwise the flat-on view presents all the advantages of perspective, and allows us to show the ground and the side walls in a much more 'realistic' fashion than axonometry. A complete element of elevation is not necessary; a profile is enough which we can draw to a fixed scale. So too the lateral walls are not necessarily perpendicular to the elevation, but in general we draw this kind of view for the orthogonal spaces.

## The view of the study sketch

In a nature sketch it is not always easy to put oneself in a frontal position. It is essentially a view proper to the imaginary sketch in perspective, for it can be exact and without a ground plan. We can draw it from an idea of an elevation and of a volume. It gives the feeling of being in the space shown, while with the isometric perspective (see p.32) we were outside it. The only problem is constructing the depth, which we will see on page 86.

The parallel lines of the frontal part are called 'frontal lines', as they are horizontal, vertical or inclined. (The perpendicular lines on the wall, vanishing in the perspective, are called 'ground lines')

*The flat-on view is preferred for interiors.*

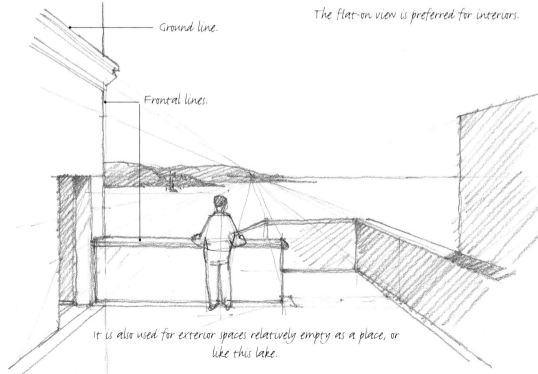

Ground line.

Frontal lines.

*It is also used for exterior spaces relatively empty as a place, or like this lake.*

# How to proceed

1 Draw the bottom panel.

2 Define the height of the horizon that corresponds well to the eye level of the observer.

3 Choose a position of the vanishing point on the horizon, left, right or centre, corresponding to the possible positions of the observer, as we have seen earlier.

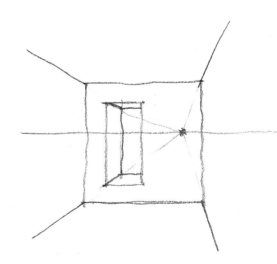

4 Then draw the vanishing lines which delimit the side walls and the shape of the ceiling.

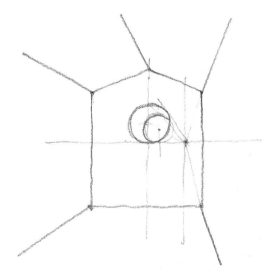

More complicated shapes can be drawn in perspective.

## The problem of depth

The problem is that nothing *a priori* allows us to define depth. For example, if you want to draw a room with a depth double the width, you have the width on the base drawing, but not the means of knowing the depth.

Here is a simple method to find this depth, on the figures on the ground, in order not to complicate the drawings. The volumes are deduced immediately by elevation as soon as we have the depth on the ground.

## Instructions for the square in perspective

Imagine the drawing on the ground of a rectangular figure. Look at the drawings below. They show the same figure, shown at three different distances. The further away we are, the more the seen part flattens out. (You can verify the phenomenon with a book held in front of you.) The figure shown here is a square seen at different distances. That could also well be a rectangle of 1 on 2, seen at another series of distances.

Let us assume that it is a square seen at a certain distance, and let us consider the diagonals of this square. Each of these diagonals is a straight line which has a vanishing point on the horizon, one at D1, on the right, and the other at D2, on the left. Moreover, we know that the diagonals of a square make angles of 45° with the sides, and so here these two vanishing points can be called 'vanishing points of directions at 45°' in relation to the direction of the bottom (which is looking at the principal vanishing point O). Note too that the position of point O is not important; it is not necessarily at the centre. From this we gather that if we have a front length and a vanishing point at 45°, we can draw the depth equal to this distance.

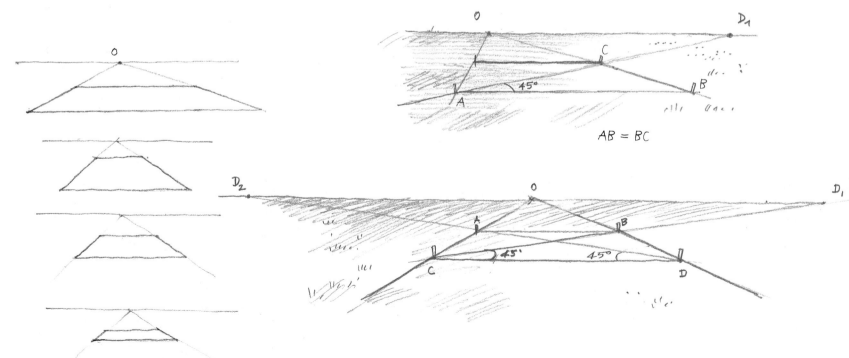

AB = BC

## Points of distance

In fact, these points at 45°, D1 and D2, are called 'points of distance'.

The sketches 1 and 2 below show how the directions at 45° are organised in relation to the picture plane, and the triangle rectangle formed by the directions at the bottom is at 45°. You can see how the distance at which the observer is placed from the picture plane is equal to the distance, on this picture plane, between the central vanishing point O and the point D1.

①

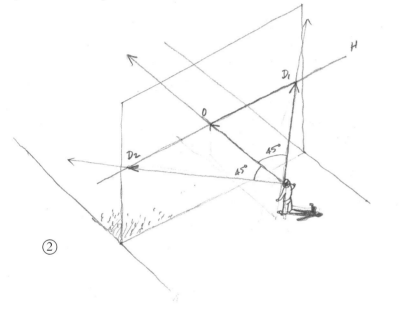

②

## Measuring the depth: an exercise in synthesis

1    Assuming that we are drawing at a scale of 1/100, begin with a horizontal line on the ground, then the horizon (H) will be about 1.5m high (1.5cm at 1/100) above the line of the ground (T). The distance from the observer is chosen at 10m, so we have OD=10cm.

2    You want to draw the perspective of a straight line on the ground, 3m in front of the line T. Draw AB=3cm on T. Draw and intersect OB and AD. The intersection B' gives the distance.

3    If you want to place a length of 4.5m (AC), put it first on T, then make it come to A'C'. If you want the 4.5m to start 2m from A, place them thus, this allows you to place A'B' in consequence. Don't mistake the distance (3m, AA') with the length of the segment AC moved to A'C' (4.5m). (NB: the underlining under the distances means 'in perspective'.)

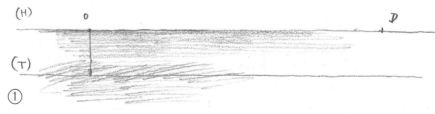

①

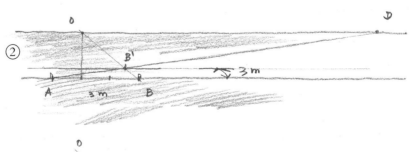

②

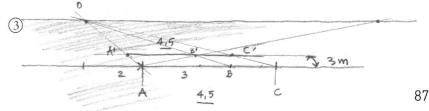

③

87

## Constructing in a space freehand

How can one place in perspective point P, starting from its coordinates in x,y,z, taken, for example, from an origin O which can be the middle of the ground line T?

We define the axes of location: Ox (the position in width), Oy (the position in depth), Oz (the height).

1   To place a point in perspective, place successively, starting from O, the distance x, the depth y and finally the height z, on the vertical line at the end of Ox.

2   Then combine the data, first to place the depth P with Oy and the point of distance.

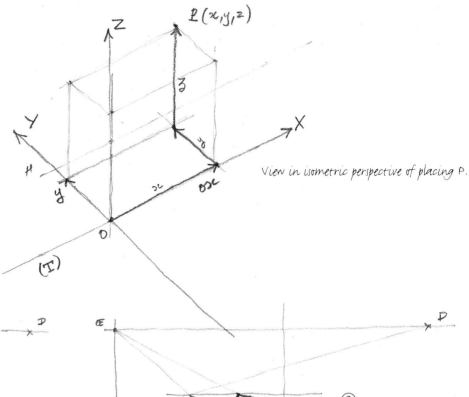

View in isometric perspective of placing P.

1 We draw Ox on the ground line.

2 Then we draw back from a depth y towards OE.

3   You obtain the final position by projecting the height xz.

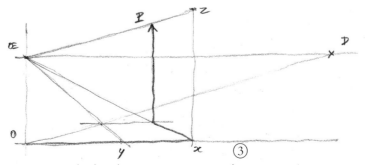

3 We raise the height z (measured on the picture plane in xz).

The heavy line shows how the point obtained can be seen as the result of a journey in space, leaving from O, by Ox, then Oy, then Oz.

## Doing without the distance point

The distance point (see p.87) is useful, but not always practical, as it means a large width of the drawing not used. To avoid this constraint, there is a trick which consists of making not a straight line of 'distance', but a straight line of 'double distance'.

1    Start by drawing the beginning of the normal distance line, without finishing it (D), since the point D would be outside the drawing and the sheet of paper.

2    Place a segment AB. Draw a vanishing line BOE. By definition, A(D) being the straight distance line, BB' is equal to AB.

3    Then consider the segment A'B', parallel to AB. Divide it in two, then draw AC, extended then as far as the horizon towards D2. This time the straight line AD2 stays within the drawing.

This straight line intersects BOE at B". By the effect of proportion we see that BB" is double BB'.

The straight line AD2 can thus be understood as a straight line of 'double distance'. It gives us the means of constructing distances, like a straight line (D) but taking into account that the distances measured on the ground line will be doubled.

This new construction relies on the following observations:

It is rarely necessary to know exactly at what distance the object is placed.

The important thing it to put down a reasonable distance, not too short, and to keep this same distance for the whole drawing. This is what the straight line of double (or triple) distance enables us to obtain.

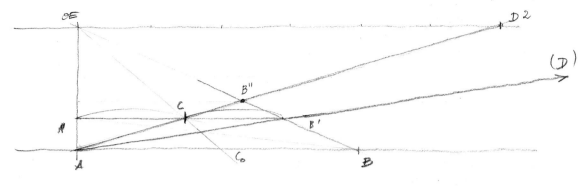

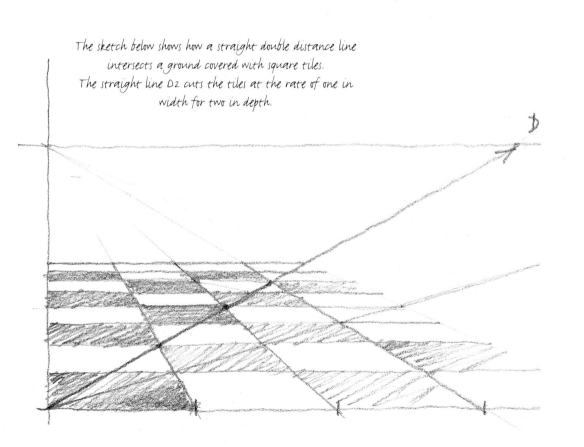

The sketch below shows how a straight double distance line intersects a ground covered with square tiles. The straight line D2 cuts the tiles at the rate of one in width for two in depth.

89

## Constructing equal depths on a wall

Draw the first divisions on a vertical line on the wall. Mark a vanishing point O' up high, anywhere, but on the plane of the wall, that's to say on the vertical line from OE. Draw the vanishing lines towards this point O'. By intersecting with a horizontal line, you obtain the equal divisions.

## Constructing equal depths on a plane

The construction resembles the one for constructing equal depths, but here we are not finding the amount of depth, but simply making sure that the distances are equal, as the chosen vanishing point O" is anywhere.

Start by drawing equal divisions on a line parallel to the horizon, then join the points of these divisions with a point somewhere on the horizon. These vanishing lines intersect a vanishing line towards the principal vanishing point OE, according to a regular division.

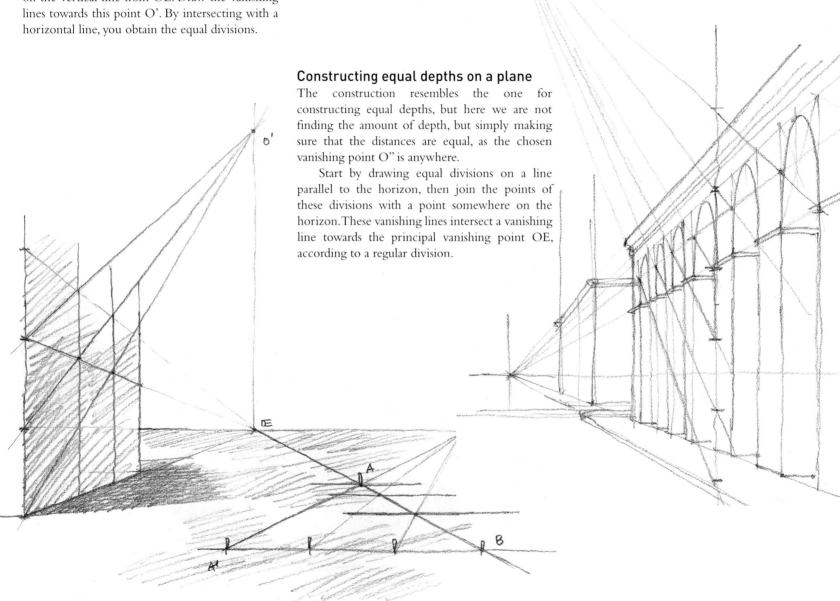

## The distance of the draughtsman

When you look at a drawn perspective, you usually have to place yourself opposite the main point, and at a distance from the drawing which is the same as that which separates the main point from the distance point. In this position you will have usually have the same view as the artist. It's not essential, and the drawing is comprehensible even viewed at an angle, but it gives a much more accurate view.

The converse is equally true: when drawing, note what distance you are from the paper, and imagine the point of distance, to right and left, at the same distance.

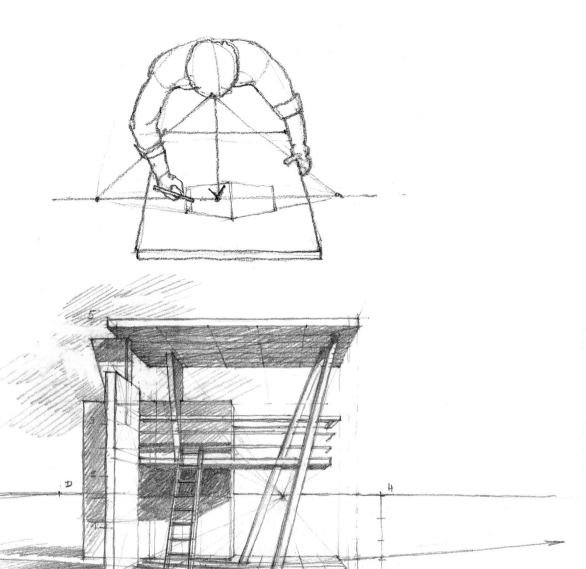

# View to the front, view to the back

In the first case the perspective is constructed from the back wall, we call it view ahead, for it develops in front of this wall. In the second case, it is the front wall which is the point of departure, and the perspective develops as it moves away. The picture plane is thus supposed to be transparent, like a window.

## View to the front

Here, it is a question of showing a space with double height, making a mezzanine floor. Be careful: the drawing for this is bigger that the one for the view behind, so you will need a enough paper for a space all around.

The back wall will be drawn 'geometric' and preferably to a given scale (eg1/50) or at least, if it is a simple sketch, noting the units of size as I have done here, by little points marking the metres (the drawing is done on a light paper with a grid underneath). Choose first the position of the observer, laterally OE: here at 1 metre from the left wall.

Then, place point D far enough from OE to suppose a reasonable distance. Here, supposing a back wall 5 metres wide and 10 metres high, we are positioned at the back of the room, thus at a distance OED of 10 metres. In this situation the volume of the sides interrupts where the angle of vision becomes too large, which gives the drawing its star-like structure.

We want to construct a mezzanine in an angle, the outline being drawn on the bottom wall. (It's high up, but that changes nothing). The depth (3m) is placed AB on the bottom wall, then brought back by the diagonal DBA'. We thus have the depth in AA'. All that is needed is to finish and embellish the drawing.

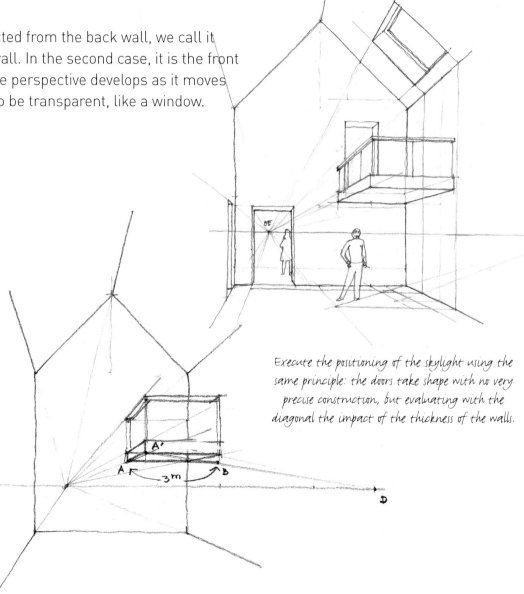

Execute the positioning of the skylight using the same principle: the doors take shape with no very precise construction, but evaluating with the diagonal the impact of the thickness of the walls.

## View to the back

Here, it is the panel AMNP that is the point of departure. It is a front wall, and the perspective develops as it extends. The panel is thus supposed transparent, like a window. This time the drawing does not exceed the size of the starting panel, and the distance point is not too far away.

1    We put in first the depths AB and AC on the bottom of the panel, in front, but this time the depth goes towards the back of the room as the diagonal AD.

   We construct a recess between two parts of the room: The first wall, on the right, is at 4 metres (given by AB and AB') then the foot is 3 metres further (BC and B'C'). The heights are deduced naturally in mounting towards the vanishing lines leading from the principal point OE.

2    From there we entertain ourselves by studying and deconstructing the left part, 1 metre high. The measurements are taken from the starting point, the threshold giving a good scale.

3    We construct a staircase in profile, according to the drawing of the two edges of the front panel: that of the top landing and the bottom landing, organising a staircase of 2 metres and six steps. We can then develop the space, the measures being deduced step by step.

*Watch out for the vanishing lines: if their drawing is precise, their outline ABCD lines up with A'B'C'D', but a discrepancy can occur very quickly if you are not careful.*

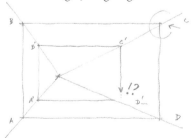

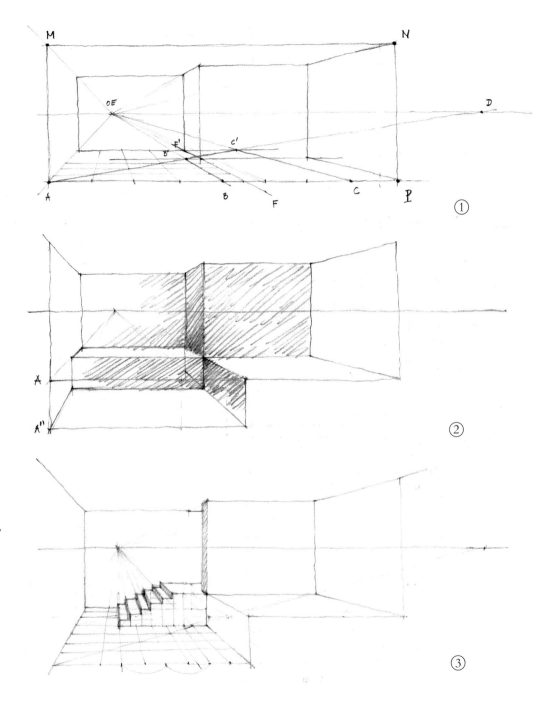

# THE OBLIQUE VIEW

This is the most usual view, the one you have when looking around a town
at random.

The direction of the view (or that of the picture plan which is perpendicular to
it), is not important in relation to the main direction of the objects observed.

Thus there is no longer a central vanishing point, as with the face on view.

We call it 'oblique' here as opposed to 'face on', but it is rather the direction
of the constructions that are oblique in relation to the eyes.

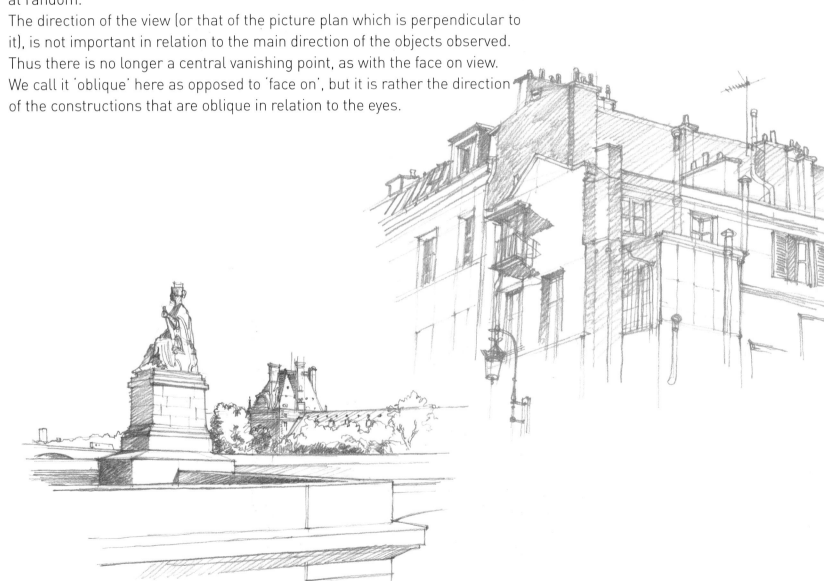

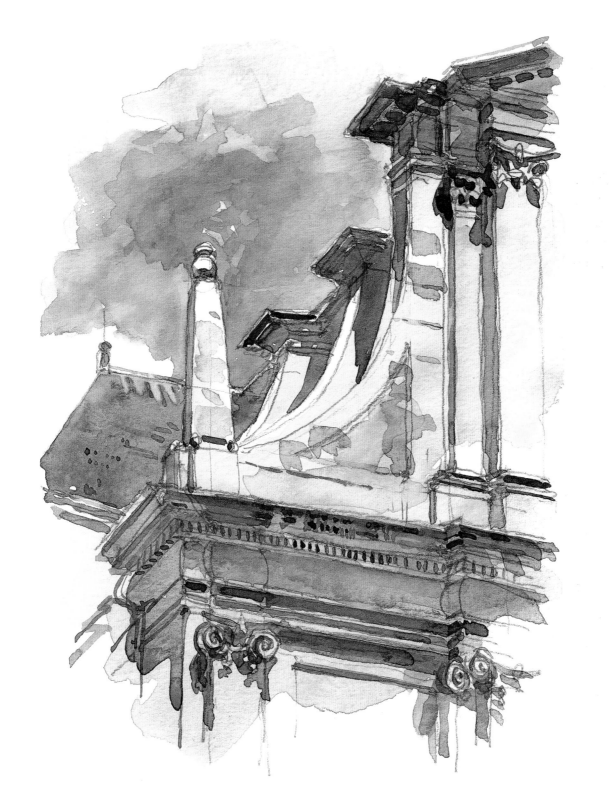

# The oblique view or at an angle

This is a perspective in which numerous vanishing points can be located, but in general we find two main ones. It is so-called in contrast to the frontal view which only has one vanishing point.

Apply the general principles of perspective, notably the location of a vanishing point.

### The perspective with two vanishing points...

It is also called that because we suppose that the objects are in an orthogonal frame, parallel to each other, which is not always the case. In fact, there are as many vanishing points as there are interesting directions.

This perspective does not offer the possibilities of the frontal view, and as our approach is limited to a sketch, leaving aside the complete methods of construction starting with a ground plan, it can only be understood by making a sketch from life.

### ... is not fundamentally different from the frontal view

The sketches below show how the rotation of an object, or of the observer, makes a move from the frontal view to the side view, and brings in a second vanishing point when the front lines find themselves at first lightly, then more and more at an angle.. This is why it is also called the 'view at an angle'

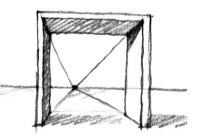

Face on view, with a single vanishing point, opposite.

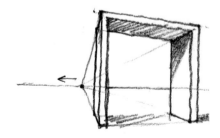

The observer moves slightly towards the left, and the vanishing point does the same.

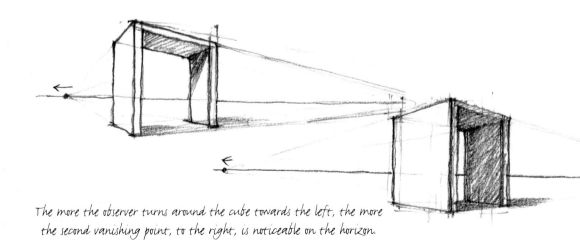

The more the observer turns around the cube towards the left, the more the second vanishing point, to the right, is noticeable on the horizon.

## Multiple directions and vanishing points

The view of the mediaeval chateau of La Brede, below, shows how we can encounter situations where there are multiple directions and vanishing points. Some are in the drawing, and others are too distant on the horizon to be visible in the drawing, when the directions are nearly parallel to the sheet of paper.

It is therefore a perspective in which numerous vanishing points have to be located, distinguishing between the horizontal lines which are vanishing off at an angle and those that are on a slope. It is not always obvious, and in the example below you have to study the form and structure of the roofs in order to understand the slant of some of the lines.

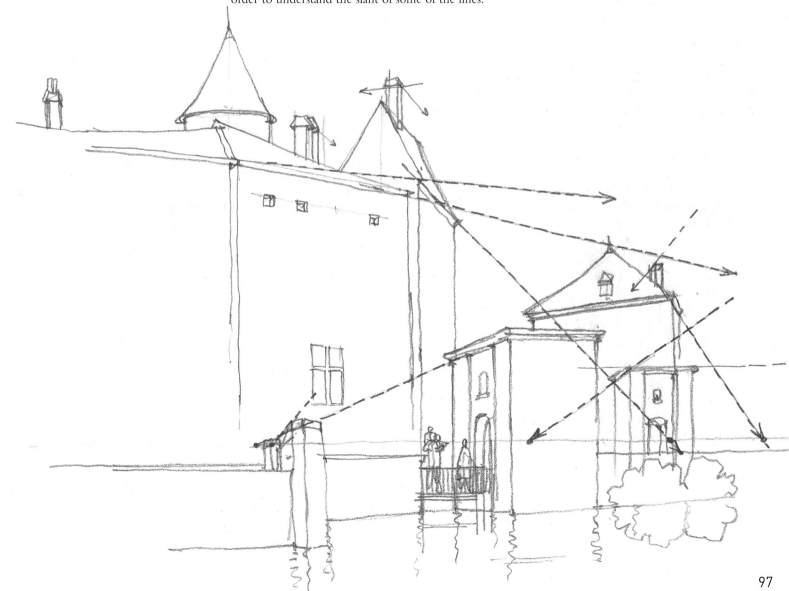

97

## How to manage without a vanishing point, method 1

When you are drawing from observation or from the imagination, when the vanishing point is not in the frame of the drawing, it is good to know some tricks to help the situation.

You have to draw a horizontal line passing through a given point, having the same vanishing point as a line already known. The simplest way is to base it on the divisions created by horizontal lines on two verticals, like the lines of a thin balcony, starting from a first vanishing line and the horizon.

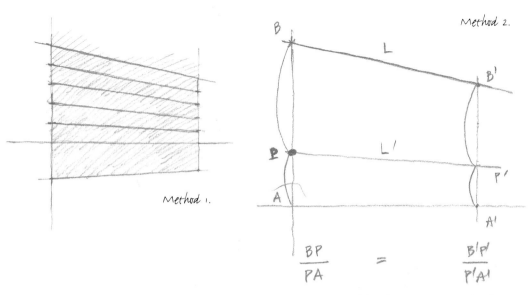

Method 1.

Method 2.

$$\frac{BP}{PA} = \frac{B'P'}{P'A'}$$

We can put in the ratio created by the two segments AP and PB.

## How to manage without a vanishing point, method 2

Starting from point P, you have to draw a horizontal line (L') vanishing towards the same vanishing point as another known line (L).

For that, first put in two vertical lines, and draw the two diagonals created with the horizon. From the intersection of the diagonals draw the vertical line that cuts the rectangle in two. From P, construct the same figure to obtain L'.

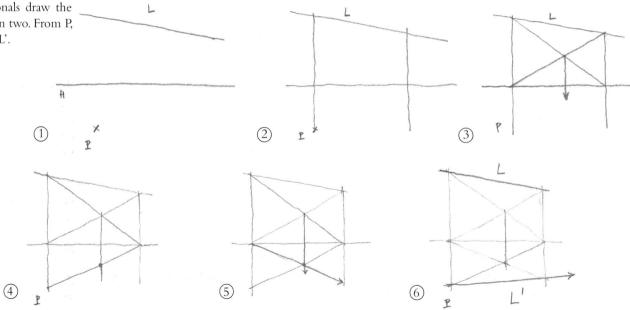

98

① 1 Two vanishing lines (F₁) and (F₂) without a horizon, the vanishing point being too far away to be placed.

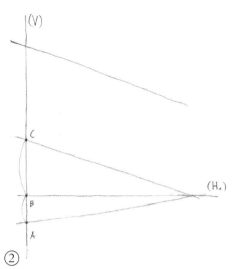

② 2 To find the horizon, repeat the sketch on a smaller scale. Draw a parallel line (F₂) to (F₁). This allows you to draw a 'pseudo-horizon' (H₁).

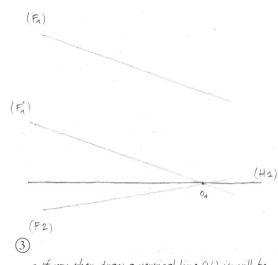

③ 3 If you then draw a vertical line (V) it will be intersected by (H₁), creating a link AB/BC.

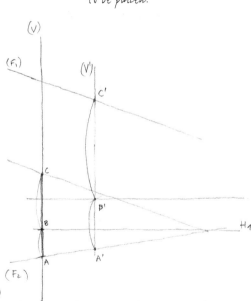

④ 4 This link is the same as the one that the true horizon would create with the vanishing lines (F₁) and (F₂). It is enough now to place it on V or more easily on another vertical line V', giving A'B'/B'C'.

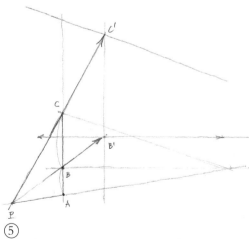

⑤ 5 If the link is not easy to put in 'by eye', you can leave from some point P on one of the vanishing lines and from there project PC towards PC' and PB towards PB'.

## Finding the horizon

Normally, the horizon is one of the first lines to be placed in a perspective drawing. In practice, we often do things in reverse, starting by putting in the vanishing lines, then saying that the horizon would be very useful.

Having already drawn two vanishing lines that do not intersect on the paper, how can we deduce the corresponding horizon? This question comes up in an imaginary sketch, for in a nature sketch the horizon can be seen in the landscape.

(Besides, this construction is useful even if the two vanishing lines are not lines on the same vertical plane, such as a façade, but for example the edge of a roof and that of the pavement.)

## Division of depth

This is a recurrent problem which we have already touched on with the equal division of a rectangle (see p.12). We can equally divide the depth in perspective by relying on keeping the proportions, and on the diagonals.

Combining the dividing into two and into three we can deal with a large number of cases.

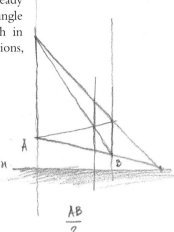

$$\frac{AB}{2}$$

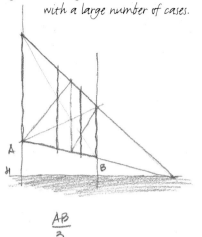

$$\frac{AB}{3}$$

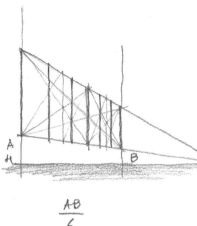

$$\frac{AB}{6}$$

The vanishing point of the sloping lines is on a vertical line with the vanishing point of the horizontal lines if all these lines are in the same vertical plane, like the ramp of a staircase, for example. First make the division on the vertical AB, then draw the diagonal line AC. Extending this, you obtain a high vanishing point PF₁. From there you can bring the divisions to the horizontal BC then bring them down vertically.

To make a similar division on the horizontal plane, draw a frontal segment leaving from one of the ends of the base, then divide this segment as you like. Then join the last point obtained (here M) with the other end MA, giving the point PFT. Transfer MND on to AB.

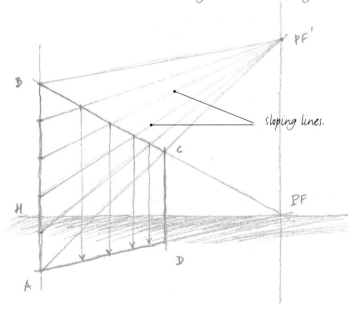

sloping lines.

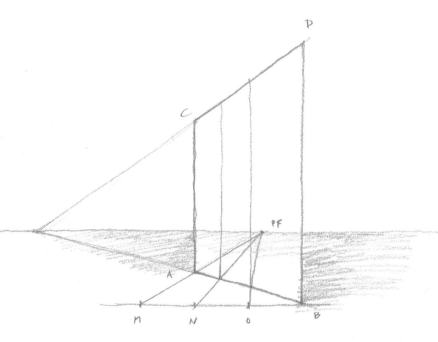

## Measuring the depth

The precise measurement of the depth, which we practised on the face on view (which is its main advantage) is much more tricky with the oblique view. In general, we construct it rigorously from a ground plan, but it is sometimes necessary to confirm that the depth on one face stays consistent with that on the other face for a simple resemblance. The method I propose will allow you to make a small verification 'behind the scenes'.

It consists of drawing a sketch of a ground plan to a very small scale. This is in order to measure the proportions of the main divisions, and to place the second vanishing point in accordance with the first points. Instead of showing the object in question on the small ground plan, we use a cube of adapted dimensions, 1 or 10 metres. This also permits us to have a scale at our disposal, and to put in the approximate positions of the vanishing points on the horizon, using the cube as a measure.

Once you have the perspective of the cube as reference, the remainder of the view can be done by eye, using the diagonals.

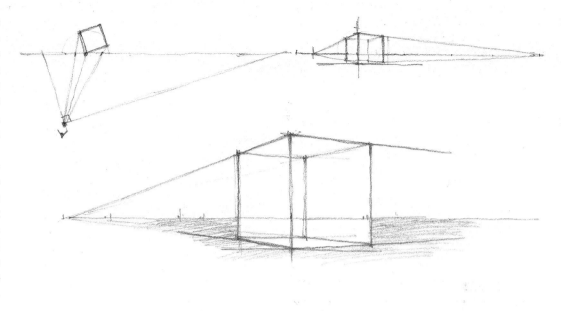

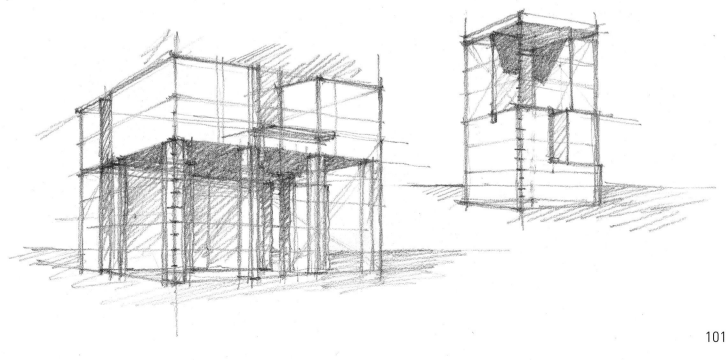

# View from above… and below

How do we organise what we are looking at when the view is not horizontal? Up till now, we have always made the hypothesis that the vertical lines in reality are vertical in the drawing. This corresponds to the most usual situation. But if we are looking steeply upwards or downwards, the view is transformed.

## View downwards

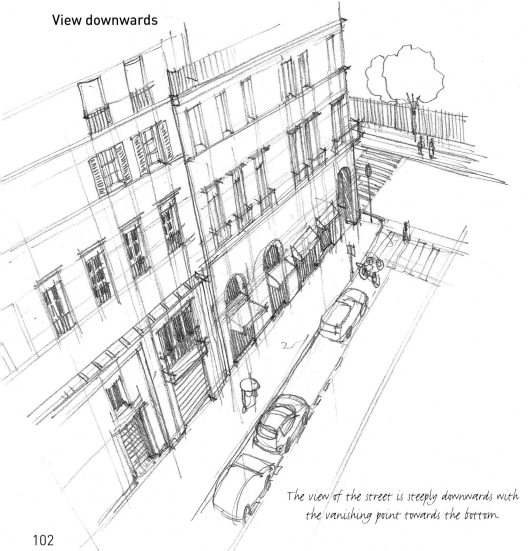

The view of the street is steeply downwards with the vanishing point towards the bottom.

The view is horizontal, with the horizon high in the drawing, which allows us to orientate the view towards the bottom.

Looking downwards, there is a convergence of the vertical lines. They seem to converge in the distance, exactly like the horizontal lines in a horizontal view.

If we accentuate the steep view, the vanishing point comes into the field of vision.

## The view upwards

In the upwards view the effect is exactly the same, but towards the top. This upwards view is much more difficult to draw, for naturally we are holding the paper under our eyes and we have to go backwards and forwards between the view and the drawing!

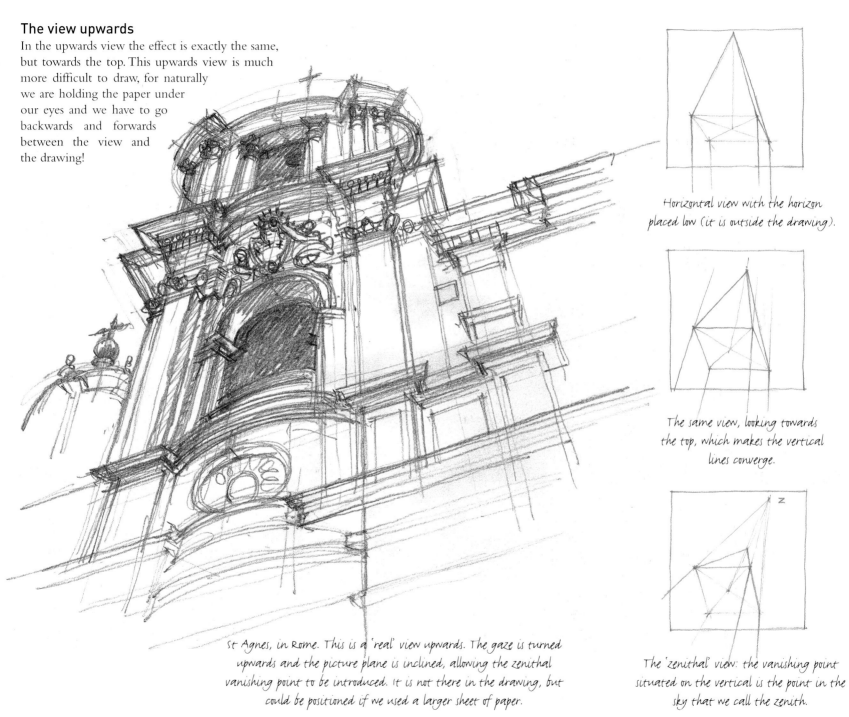

Horizontal view with the horizon placed low (it is outside the drawing).

The same view, looking towards the top, which makes the vertical lines converge.

The 'zenithal' view: the vanishing point situated on the vertical is the point in the sky that we call the zenith.

St Agnes, in Rome. This is a 'real' view upwards. The gaze is turned upwards and the picture plane is inclined, allowing the zenithal vanishing point to be introduced. It is not there in the drawing, but could be positioned if we used a larger sheet of paper.

# Memorise a basic sketch

The oblique view, in imaginary sketches, lends itself to various types of sketch, allowing you to draw a satisfactory view instantly, without too much application of perspective. You can easily memorise them, and use them to sketch a view of a project.

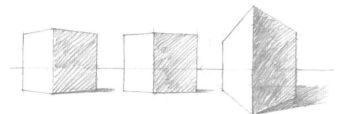

*If we are too far away, the effect of perspective is imperceptible; if we are too near, perspective is not false, but exaggerated, and we no longer look at the object, but the perspective.*

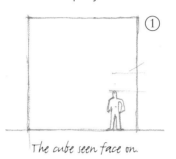

① *The cube seen face on.*

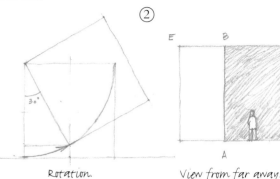

② *Rotation.* *View from far away.*

## Observation

View of a cube with a 5 metre side, situated about 12 metres from a pedestrian, with a horizon at 1.60 metres and rotated 30/60. We suppose that the pedestrian is just in front of the front edge. This allows us to construct multiple drawings. The rotation of 30, or its converse, 60, constitutes the useful intermediaries between the frontal view and the symmetrical 45 view, which is not very interesting.

NB The following description does not give details of the construction, just indications of how to draw the cube seen here, and noting which measurements to memorise.

1    The cube seen face on.. We suppose that the plane of this face is going to be the picture plane and that the view here will always be perpendicular.

2    A rotation of 30 of the cube brings about the following view if we are far away. The relationship beween the two apparent widths of the two faces seen (measured on the top edges EB and BC) is half the side of the cube on the left, and 0.86 on

the right. Memorise half the height to the left and a good 1/10 less than the side on the right. This relationship does not change much when we approach, and we can consider it as invariable whatever the distance.

3    Suppose that we approach to see the perspective, so that we are always straight in front of the front edge. The edge AB then distends vertically into A'B'. This distension is not the same from top to bottom of the edge, but is proportional to the division given by the horizon on the edge. In fact, as soon as we are in perspective, and not in elevation, a horizon appears, defined by the height of the eye, thus 1.6 metres, which we can mark on the 5 metres of the front edge.

As the cube is 5 metres tall, the horizon is a little lower than a third of the cube and we obtain a point C', with CC'equal to a third of BB'. In fact, the whole ensemble grows, but for the drawing, here, we will keep the fixed base, imagining that the scale of reproduction reduces as the object grows.

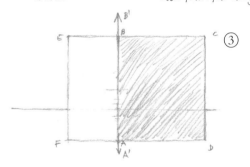

③

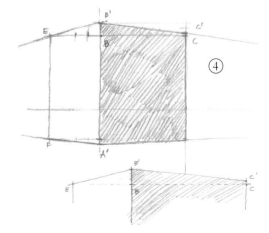

④

## How to proceed

All this is only approximate, but can be useful to make a simple sketch.

1   Draw a vertical line AB, which will be the vertical front edge of a cube, of a suitable size for the drawing.

2   Then place the horizon and a person who will help to show the scale.

3   You put in the two lateral edges (BE and BC) and you can very lightly sketch the cube in elevation by two horizontals top and bottom. Draw the two vanishing lines B'E and B'C according to which is said to be higher. In placing B' above B at 1/4 the length of BE and C' at 1/3 the length of BB'.

At the bottom place A' and draw the two vanishing lines leaving from A' just as the diagonal A'PDF.

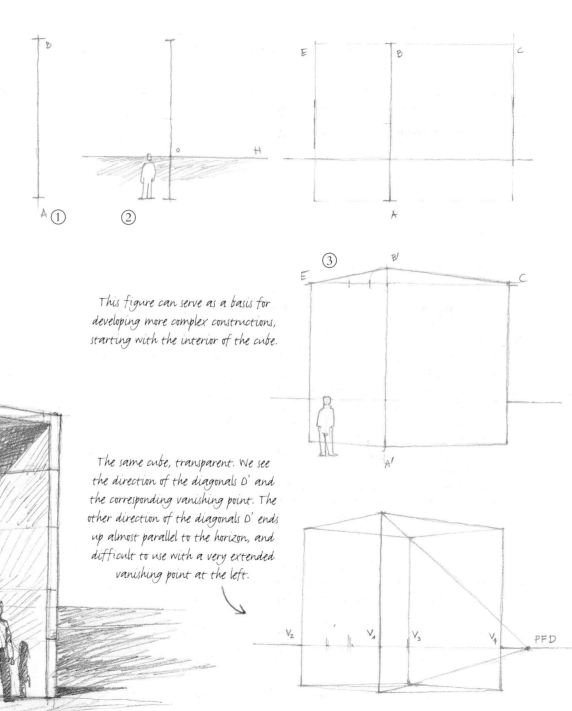

This figure can serve as a basis for developing more complex constructions, starting with the interior of the cube.

The same cube, transparent. We see the direction of the diagonals D' and the corresponding vanishing point. The other direction of the diagonals D' ends up almost parallel to the horizon, and difficult to use with a very extended vanishing point at the left.

105

# Staircases

Going up or down, a staircase always attracts our attention. But drawing a staircase is complex for a beginner, because he doesn't know which end to start at, and how to simplify it.

### Sorting out the starting lines

First of all remember that a staircase has a slope of about 2/1: the length is double the height (an inside staircase is a little more steep). Respecting this proportion, which is the same for a single step, is essential.

Locate the staircase in a simple orthogonal structure, and observe that the lines of the staircase are sloping, but parallel, and that they therefore have a vanishing point like the others.

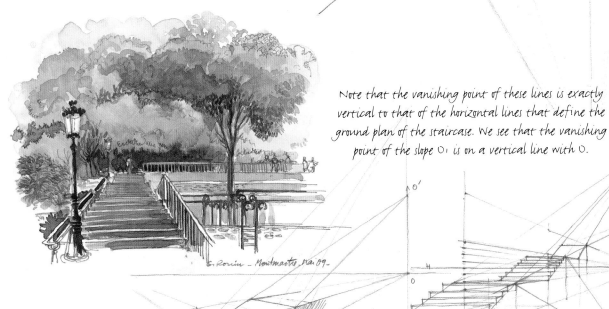

*Note that the vanishing point of these lines is exactly vertical to that of the horizontal lines that define the ground plan of the staircase. We see that the vanishing point of the slope $O_1$ is on a vertical line with $O$.*

*A development of the preceding drawing.*
*Don't be alarmed by the many vanishing points: $O_1$ is that of the slope, and is the only one with a general function. $O_2$ is that of the slope, taking account of the landings which, reducing the slope, make the vanishing point lower... and $O_3$ is only there for a reminder: if the landings have the same length, we can always find a vanishing point, towards the foot eventually.*

## Getting the slope right

If there are a lot of steps, we work by eye, but if there are a few, mistakes show up immediately. Beware of the current error which consists of thinking that the slope corresponds to the line AB. If you assimilate the demonstration below, dividing the steps becomes child's play. Divide the slope into equal steps and mark out vertically and horizontally if necessary.

A staircase without the steps, limited to the space between the foot of the first step (A) and the edge of the last step (B). In this way we can perceive instinctively the boundaries of a staircase.

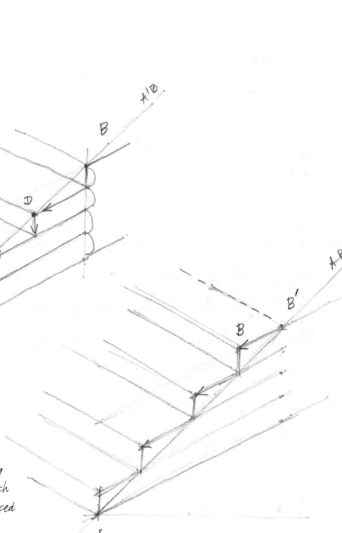

In fact the slope links A' and B. After having placed A', it's enough to join A'B.

If we want to draw the slope beginning at A, we have to create a point B' which represents the end of the top step, unnoticed in the landing.

107

# Roads, streets and pavements

In towns the ground is neither flat nor horizontal, for even if the terrain seems flat, artificial slopes are organised to ensure that rain water drains away. Only the interiors of buildings escape this rule. Showing slopes, undulations, the contours between roads and pavements or between pavements and facades proves to be very important to the realism of the sketch.

### A street with a steep slope

1    This sketch shows a street in Sarajevo with a very steep slope. The horizon placed here (H) is not visible in reality because it is hidden by the bottom of the mountain. We see there a vanishing point, PH, of horizontal lines such as the roof tiles on the left or the windows on the right. Another vanishing point PB is hidden at the bottom, that of the nearest street pavements (afterwards this turns left then becomes horizontal). Each bend in the street corresponds to a new vanishing point.

2    The same street, seen in the other direction. This time the horizon is hidden by the street itself, and on a vanishing point PH of the horizontals, and a point PM at the top of the street, that of the pavements and the bottoms of the houses.

> You must always distinguish what is horizontal. Architectural lines are subject to the horizontal lines of interior floors, and to those of the street, depending on the natural relief. Often it is necessary to add modulations to ground plans, because of the undulating terrain.

*The meeting between horizontal and vertical surfaces gives the characteristic lines of the urban ground.*

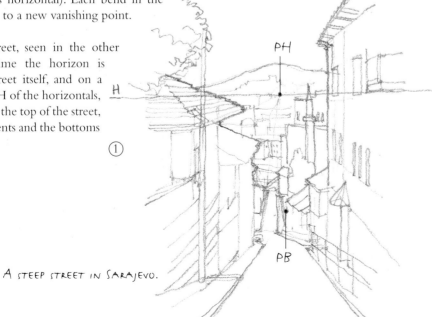

PH

H

①

PB

A STEEP STREET IN SARAJEVO.

②

PM

PH

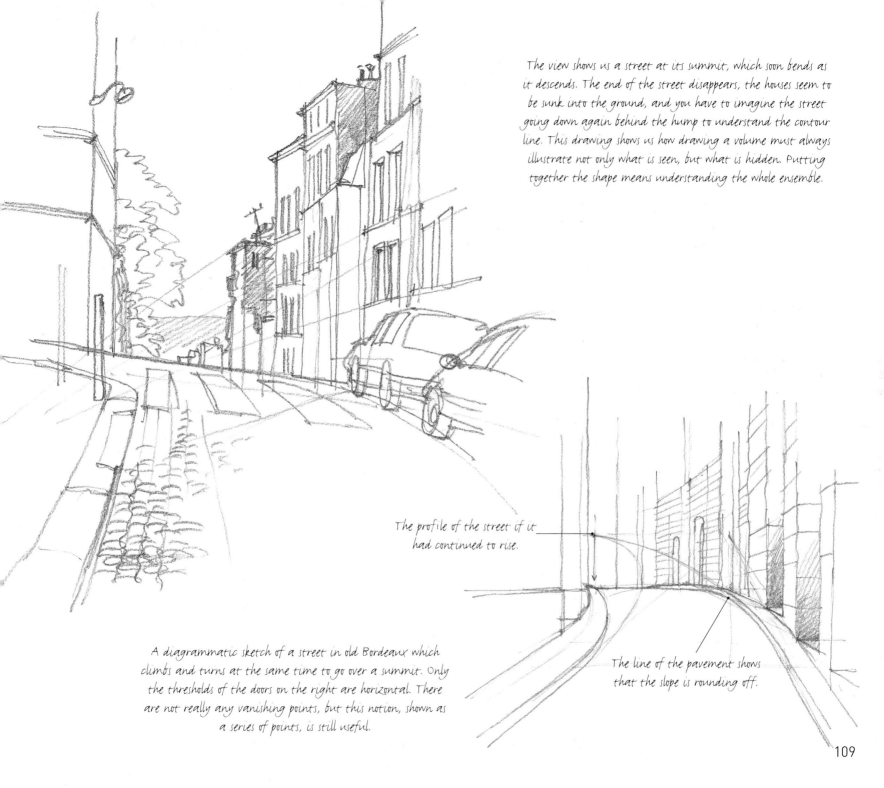

The view shows us a street at its summit, which soon bends as it descends. The end of the street disappears, the houses seem to be sunk into the ground, and you have to imagine the street going down again behind the hump to understand the contour line. This drawing shows us how drawing a volume must always illustrate not only what is seen, but what is hidden. Putting together the shape means understanding the whole ensemble.

The profile of the street if it had continued to rise.

The line of the pavement shows that the slope is rounding off.

A diagrammatic sketch of a street in old Bordeaux which climbs and turns at the same time to go over a summit. Only the thresholds of the doors on the right are horizontal. There are not really any vanishing points, but this notion, shown as a series of points, is still useful.

109

# Roofs and Cornices

As on the ground, roofs also necessitate an analysis of what is hidden. On the other hand, if the problem is generally simpler and more geometric, it allows less for approximation.

## How to draw the edges of the roofs

The first thing to understand is that the slope of a roof is usually the same all the way round, for aesthetic reasons, but also for geometric simplicity depending on the different roofing materials. You must therefore find the ground plan from the perspective, and on that the 45°diagonals, for it is from that that we can draw the hipped roof (these are the edges of the roof at the angles).

*For a rectangular roof, draw the plan, then the bisecting lines at 45° which intersect and enable us to draw the central roof line; this is then projected vertically to give the ridge line*

*45°*

*Bisecting lines.*

*To find the centre (and the point) of a square roof, draw the centre of the square base of the roof, with its diagonal lines, all the rest follows at the same time.*

*Note that a detailed roof is only the elaboration of this geometric structure, both simple and rigorous.*

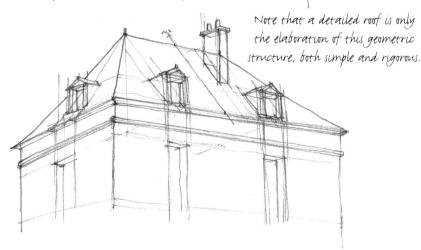

## How to draw the cornices

One of the most tricky subjects in architectural drawing are the inevitable cornices, the mouldings, and particularly the angles.

The best method, even if it is a little long, is to analyse the volume. This entails locating some non-apparent lines: the profiles on each side and their prolongation until they intersect at angles from which it is easy to draw the lines of the cornices. This operation must be done at least mentally, observing the angle of the cornice, otherwise you are faced with a multitude of lines impossible to untangle.

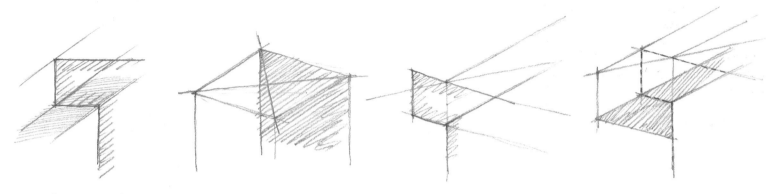

*Draw the profile of the cornice, extending the lines from one of its sides.*     *Then extend it to meet the lines at 45° from the angle.*

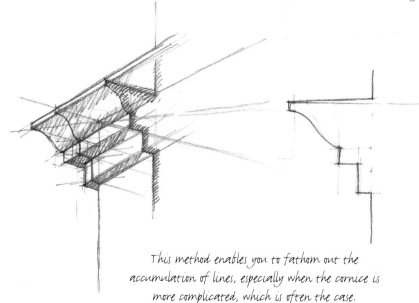

*This method enables you to fathom out the accumulation of lines, especially when the cornice is more complicated, which is often the case.*

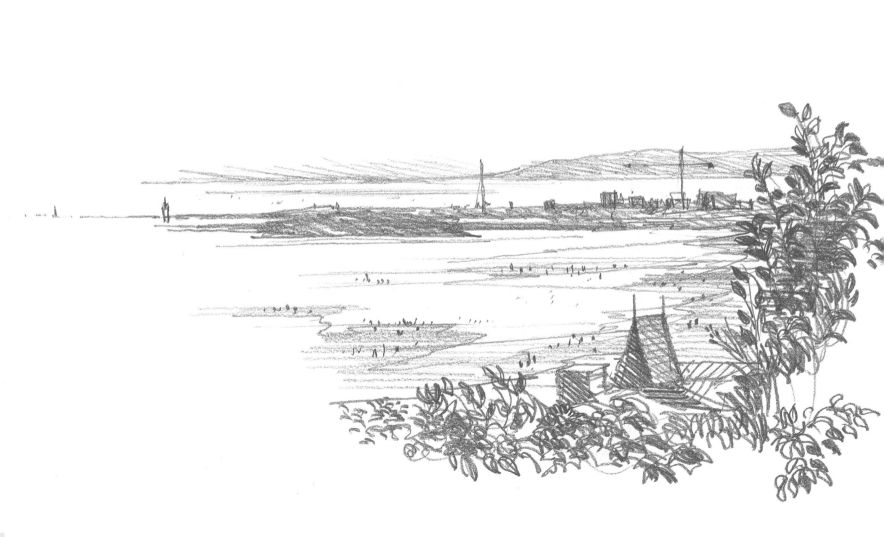